IMAGES
of America

DIAMOND BAR

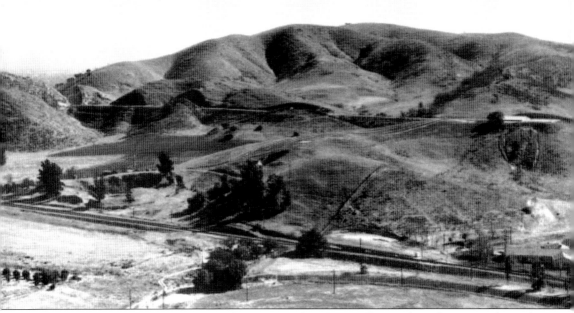

This bird's-eye view of the Diamond Bar area, taken from Valley Boulevard in 1936, shows the beautiful rolling hillsides covered with stands of sycamore, oak, and walnut trees. The formation in the center of the photograph, often referred to as Elephant Hill, is what remains of a dormant volcano that dates back five million years. In the early 1930s, a roadway was constructed to connect the Spadra area to Pomona, or Fifth Avenue (present-day Golden Springs Drive/Diamond Bar Boulevard) through to Mission Boulevard. (Courtesy of Frasher Fotos.)

ON THE COVER: This 1940 photograph shows branding time on the Diamond Bar Ranch. Pictured here are ranch manager Ezra Hayes and cowboys Angel Reyes and Bill "Slim" Potter. These longtime ranch hands worked for both Frederick E. Lewis and William Bartholomae at the Diamond Bar Ranch between 1918 and 1956. (Courtesy of Bill Potter.)

City of Diamond Bar and
Diamond Bar Historical Society

Copyright © 2014 by City of Diamond Bar and Diamond Bar Historical Society
ISBN 978-1-4671-3196-4

Published by Arcadia Publishing
Charleston, South Carolina

Printed in the United States of America

Library of Congress Control Number: 2013955788

For all general information, please contact Arcadia Publishing:
Telephone 843-853-2070
Fax 843-853-0044
E-mail sales@arcadiapublishing.com
For customer service and orders:
Toll-Free 1-888-313-2665

Visit us on the Internet at www.arcadiapublishing.com

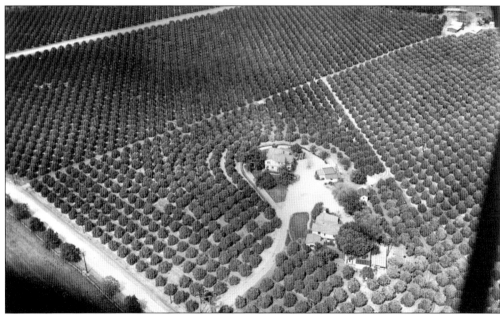

During the early 1900s, the citrus industry flourished in the Pomona Valley. The McMillan Ranch and Citrus Nursery was one of the largest nurseries in the Diamond Bar area. Two brothers, Charles and George McMillan, owned groves that stretched for approximately 200 acres from Valley Boulevard to the north along Brea Canyon Road (the road on the left side of the image) toward Pathfinder Road. This 1930s image is an aerial photograph of the McMillan groves. (Courtesy of the McMillan family.)

Contents

Acknowledgments 6

Introduction 7

1. Early Years: Land Grants, Ranchos, and Ranches 11

2. Diamond Bar Ranch: New Era for Rancho Los Nogales 25

3. Transamerica: Blueprint for a Master-Planned Community 59

4. Road to Incorporation: New Beginnings 101

5. Growth of a City: The First 25 Years 119

Acknowledgments

The Diamond Bar City Council thanks all those who have contributed to and dedicated themselves toward the establishment and preservation of the city of Diamond Bar. The council recognizes the efforts of the Diamond Bar Historical Society, including founding members Don Gravdahl, Marilyn Kieffer, Kathleen McCarthy Newe, Arlene Navarro, and Glennon Neubauer, as well as charter members John Isaac, Harriet Isaac, Genevieve Peterson, Rose Repar, Jack Tillery, and Eileen Tillery, and—in particular—former Diamond Bar mayor and historical society founding member and president John Forbing, for the foresight to ensure the preservation of the city's history and safeguarding our treasures for all these years.

Appreciation also goes to the members of the Diamond Bar History Project, with special recognition to Greg M. Busch for his tenacity and unparalleled detective skills in uncovering our city's past. Thank you to Bill Bartholomae for his commitment to preserving the Diamond Bar Ranch's rich history. It is impossible to individually thank all those who have contributed photographs, artifacts, memories, and time throughout the years to preserve the city's history, but their hard work and dedication have made this book possible.

In addition, we acknowledge the following city staff members: city manager James DeStefano, assistant city manager David Doyle, deputy city manager Ryan McLean, public information manager Marsha Roa, public information coordinator Cecilia Arellano, and city clerk Tommye Cribbins, who, as the city's first employee, celebrated her 25th anniversary with Diamond Bar in 2014.

We must also recognize the contributions of the early settlers for their fortitude and all the visionaries for their ability to create what most only imagine. Thank you to all the past members of the Capital Corporation, Transamerica Development Company, Transamerica Corporation, Diamond Bar Homeowners Association, Diamond Bar Municipal Advisory Council, Diamond Bar Improvement Association, city council, city managers, commissioners, and community members for laying the foundation from which all has grown.

Unless otherwise noted, all images are courtesy of the Diamond Bar Historical Society. Some images are courtesy of the Historical Society of Pomona Valley, which is abbreviated throughout the book as "HSPV."

Diamond Bar City Council members

Name	Term	Name	Term
Phyllis Papen	1989–1995	Bob Huff	1995–2004
Paul Horcher	1989–1990	Carol Herrera	1995–present
John Forbing	1989–1993	Wen Chang	1997–2009
Gary Werner	1989–1997	Debby O'Connor	1997–2005
Gary Miller	1989–1995	Bob Zirbes	2001–2007
Jay Kim	1990–1992	Jack Tanaka	2005–present
Don Nardella	1990–1991	Steve Tye	2005–present
Dexter MacBride	1992–1993	Ron Everett	2007–2013
Clair Harmony	1993–1997	Ling-Ling Chang	2009–present
Eileen Ansari	1993–2001	Nancy Lyons	2013–present

INTRODUCTION

For thousands of years, the Tongva people inhabited the region that encompassed the entire Los Angeles basin. They ruled the region relatively unchallenged until Spain established the first European settlements in California in 1771.

The first settlement in the area was Mission San Gabriel, which was established near the San Gabriel River in 1776. San Gabriel flourished and soon became one of the most successful of the 21 missions, with large numbers of livestock and vast farmland extending far eastward to encompass the rolling hills and valleys of present-day Diamond Bar.

As the missions flourished, their influence and power grew throughout California, and when Mexico became independent from Spain in 1821, a movement began to reduce Spanish power and distribute their lands. The secularization of the missions began in 1830, and the first land grant in the Pomona Valley was issued on April 15, 1837, when Mexican governor Juan Bautista Alvarado conveyed a 22,000-acre parcel of land to California natives Ygnacio Palomares and Ricardo Vejar, who named their new home Rancho San Jose.

In 1840, a second land grant, containing approximately 1,004 acres south of the San Jose Creek, was deeded to Jose de la Luz Linares. This property, which he named Rancho Los Nogales (Ranch of Walnut Trees), is the current location of the city of Diamond Bar.

After Linares died in 1847, his widow, Maria, sold a choice portion of the ranch to Vejar, who already owned the adjacent Rancho San Jose, for $100 in merchandise, 100 calves, and the assumption of her late husband's debts. Over the course of the next 10 years, Vejar, along with his sons Ramon and Francisco, obtained possession of the entire original Los Nogales land grant, increasing his land assets to more than 13,000 acres and making him the fifth-wealthiest landowner in Los Angeles County.

Like other area ranch owners, Vejar was land rich but cash poor, so he resorted to borrowing money to feed his cattle and keep his land. He mortgaged his property but was unable to repay his loan, and in 1864, his property passed to the ownership of the merchants.

Soon after, the merchants sold the land and everything on it for $30,000 to a young livestock trader named Louis Phillips. Over the next few years, Phillips parceled large portions of the former ranchos and sold the land to new settlers from the South who were trying to escape the devastation of the Civil War.

One of the first settlers to whom Phillips sold a portion of the ranch was William "Uncle Billy" Rubottom, who established a tavern and overland stage station (for the Butterfield route) near where the Orange Freeway (Route 57) now crosses Pomona Boulevard. He called the community Spadra, after his hometown in Arkansas, and this became the first named settlement in the area.

Over the next 50 years, the modern age came to the area via the railroads and neighboring settlements, but the Rancho Los Nogales area remained much the same as it had been when Vejar and Palomares settled it.

The legacy of the bountiful land continued when Frederick E. Lewis II, a young man from New York, visited California in search of the perfect setting to fulfill his boyhood dream of owning a ranch. It took him several years to discover the rolling hills and tranquil valleys of the former Rancho Los Nogales, but in 1918, Lewis purchased 7,800 acres of choice land near the town of Spadra, about 30 miles east of Los Angeles.

The primary focus at Diamond Bar Ranch was the establishment of a Duroc-Jersey hog-breeding operation. Lewis constructed a large, 1,200-foot-long farrowing house that could accommodate up to 250 sows and their litters. Soon, the hog-breeding operation grew to include more than 7,500 Duroc-Jersey brood sows. With that many animals to feed, Lewis discovered that the cost of raising hogs on grain in Southern California was not profitable, so he partnered with another hog farmer, A.B. Miller of Fontana, to solve the problem. The two men decided that garbage was a more cost-effective food source for the hogs, and in 1920, they secured a garbage-hauling contract from the City of Los Angeles. Within a few years, the hog business was thriving, and Diamond Bar Ranch had earned a reputation as breeders of high-quality champions.

A lesser known but much more significant activity on the ranch was the breeding of Arabian horses. In late 1918, Lewis made his initial purchase of 10 Arabian horses from the Hingham Stock Farm, owned by Peter Bradley, in Massachusetts. Bradley was credited with financing a significant import in 1906, when Homer Davenport received permission from the Sultan of Turkey to export Arabian horses. Over the course of nine years, 50 registered Davenport Arabians, whose bloodlines could be traced to that original importation, were bred on the Diamond Bar Ranch. The impact of the Lewis horse-breeding operation was of such significance that bloodlines of modern horses can still be traced to those original Lewis-bred Arabians.

Lewis operated the Diamond Bar Ranch for 25 years; in that time, he successfully transformed the rural property into one of the most respected and renowned ranches in Southern California.

In 1943, Lewis sold his ranch to William A. Bartholomae, well-known and respected businessman and president of Bartholomae Oil Corporation of Fullerton. The sale of the Diamond Bar Ranch was one of the largest land deals in Southern California. For $850,000, Bartholomae took title of the ranch's 7,800 acres. In addition to buying the ranch, Bartholomae also acquired Lewis's Balboa home, where he moored his yacht, the *Sea Diamond*.

Bartholomae, a millionaire with movie-star good looks, spent 13 years overseeing 3,000 purebred Hereford cattle on his vast property. After a reported 15-month negotiation, Bartholomae decided it was time for Diamond Bar to continue prospering and establish its place in history with a new beginning, and in 1956, the Christiana Oil Corporation and the Capital Company, a subsidiary of the Transamerica Corporation, purchased the Diamond Bar Ranch for $10 million. The companies hoped to develop the largest master-planned community in Los Angeles County.

The significant acreage of open land under single ownership, along with the fact that it was isolated from other cities yet surrounded by major commercial and industrial centers, made it the ideal setting for a master-planned community that could offer residents a bucolic lifestyle. This appeal became the prime marketing tool for the Capital Company to entice potential buyers to leave busy lifestyles in metropolitan areas for "country living" in Diamond Bar.

Following adoption of the master plan in 1958, the Capital Company promptly began work on the installation of utilities and infrastructure, including development of a potable water network to serve a community of 75,000. It formed the Diamond Bar Water Company, a privately owned public utility, to facilitate the development's water supply, with Carleton J. Peterson as its manager.

Under Peterson's direction, installation of a 4,700-foot-long water pipeline along Diamond Bar Boulevard began in January 1959. The installation of other primary improvements followed, and once in place, the Capital Company began selling a variety of different-sized parcels to select builders for the construction and sale of homes in accordance with the overall master plan.

The Capital Company was simultaneously focusing on another important aspect of the Diamond Bar Master Plan—the city's roadways. The plan called for a network of roads to emanate from a five-mile-long, four-lane highway named Diamond Bar Boulevard, as well as a large central business district at the center of town (at the intersection of Grand Avenue and Diamond Bar Boulevard) with two neighborhood shopping centers in outlying areas. To meet the recreation and leisure needs of future residents, the plan also proposed the construction of several parks in addition to an 18-hole public golf course. Education was also considered in the master plan, with sites plotted for the construction of two high schools, three junior high schools, 22 elementary schools, and even a private college.

The area's first homes were erected in 1960, and the first Diamond Bar residents wasted no time establishing the area's first homeowners' association. By way of a single meeting in October 1960, a small group of property owners created the Diamond Bar Homeowners' Association (DBHOA).

In many ways, the DBHOA turned out to be the first form of government that residents of the newly formed community turned to for assistance with resolving local issues. For years, the association served the community and acted as an effective intermediary between the residents and the Los Angeles County Board of Supervisors.

As Diamond Bar's population grew, so did the desire for local control, community identity, and a formal voice. While the idea of self-governance was often contemplated, the same conclusion was reached every time: the community did not have, and possibly never would have, a sufficient tax base to enable incorporation.

So, in 1976, as a compromise, residents created a second form of grassroots government—the Diamond Bar Municipal Advisory Council (MAC).

As an advisory body, the MAC served Diamond Bar as a liaison to the Los Angeles County Board of Supervisors, providing a forum for community residents to voice concerns and representing residents' views on land use, new development, and other matters related to county governance.

Within only a few months of operation, Diamond Bar residents had largely embraced the MAC concept because of its role as a community watchdog and assistance in such areas as traffic regulation, safety, parks and recreation, and zoning.

In the early 1980s, the MAC realized that Transamerica would soon be selling the last of its holdings and no longer overseeing the development, leaving Diamond Bar to raise its own operating funds.

There was also spreading sentiment that the Los Angeles County Board of Supervisors had stopped being responsive to the Diamond Bar area's needs for parks and commercial development while allowing developers to overrun the community with unneeded housing.

This sentiment was further compounded in late 1979 when the Local Agency Formation Commission (LAFCO) for the County of Los Angeles published a controversial report titled *Puente Hills Study*, which recommended that the northern part of Diamond Bar be placed into the "sphere of influence" of Pomona.

This recommendation riled local leaders, who saw the report as a potential invitation for Pomona and other neighboring incorporated cities to annex portions of Diamond Bar. MAC vehemently rejected the report and immediately voted to form a committee to explore the possibility of incorporation through a self-determination study that would examine everything from the area's boundaries to its fiscal viability as a city.

The study, completed in November 1980, posted figures showing that the Diamond Bar area met the prerequisites for self-governing, could sustain itself financially as a city, and would have the city operating with a $500,000 surplus the first year.

These findings conflicted with estimates later produced by LAFCO, which showed that, on the contrary, first-year expenditures for the proposed city would exceed revenue generated by more than $1 million. In spite of the negative recommendation by LAFCO, MAC decided to move ahead with investigating the incorporation process.

When the issue reached the county level in 1983, LAFCO maintained its stance that the proposed incorporation of Diamond Bar be denied because of financial shortfalls the proposed city would face in its first year of existence.

Undeterred by the bleak financial report, MAC proceeded to present its proposal for Diamond Bar's incorporation to LAFCO. MAC's perseverance paid off, and after resolving minor objections to the proposed city boundaries, LAFCO approved a resolution to put the issue of the incorporation of Diamond Bar on the ballot on November 8, 1983.

Opponents to the Diamond Bar incorporation included some MAC members who cited that incorporation was economically infeasible; that little would be gained in public services not already provided by the County of Los Angeles; and that if services could be increased, it would cost residents more in taxes.

Only 230 votes defeated the incorporation effort of 1983, largely due to voters' fears of an increase in taxes, a notion that had been instilled by the opposition.

The debate over incorporation came to a conclusion six years later, on March 7, 1989, when voters overwhelmingly approved the incorporation measure by a margin of 76 percent to 24 percent. With the incorporation election results certified by Los Angeles County on March 21, 1989, the newly elected Diamond Bar City Council delved right into the thick of creating the new city.

In the weeks leading up to its official installation ceremony, the city council met several times to organize for the establishment of the soon-to-be new seat of local government; this included securing office space for city hall, hiring three key city personnel, meeting with the county to ensure continuity of services, and drafting resolutions and ordinances.

The official incorporation of the city occurred on Tuesday, April 18, 1989, during the city council's first official meeting, which was held in the Chaparral Intermediate School auditorium and attended by more than 300 individuals. The meeting involved a series of administrative decisions, including appointing key city personnel, adopting all of Los Angeles County's laws and regulations on an urgency basis, setting the dates of future regularly scheduled meetings, and introducing ordinances to establish the mechanism by which to begin collecting the city's share of taxes collected by the county and the state. In addition to dealing with these issues, the council also had the complex yet exciting task of formulating the city's first official general plan, required by state law to be completed within 30 months following incorporation, to serve as a "blueprint" for future land-use planning.

To help undertake this city-defining task, the council appointed 30 residents to serve on an ad hoc advisory committee to review the formerly unincorporated community's general plan adopted in 1982 and create a brand-new plan that would better align with the new city's vision for maintenance and growth.

The final Diamond Bar general plan was adopted by the city council on July 25, 1995, marking an important milestone for the community. Situated on the eastern edge of Los Angeles County, Diamond Bar has grown into a modern city of nearly 60,000 residents. Over the years, Diamond Bar's business-friendly practices, low crime rates, ample open space and recreational opportunities, and award-winning schools have garnered numerous accolades, including a place among the 100 Best Places to Live in 2012 (*Money* magazine), 50 Best Places to Raise your Kids in 2009 and again in 2010 (*Bloomberg Businessweek*), 10 Best Towns for Families in 2007 (*Family Circle* magazine), and top 10 cities of affordable places to do business for two consecutive years—in 1999 and again in 2000 (Kosmont *Cost of Doing Business Survey*).

In late 2010, after nearly 21 years of leasing office space within the Gateway Corporate Center, sound fiscal planning allowed the city council to purchase a two-story building at 21810 Copley Drive as its permanent headquarters. City hall operations commenced at this location on January 3, 2012, with the Diamond Bar Public Library opening its doors on the first floor on July 28, 2012.

In looking forward to the next 25 years and beyond, the current city council plans to maintain the tradition of protecting the city's firm financial foundation through prudent revenue and appropriation policies and decisions—started by the founding council and maintained by the five generations of councils that have followed—in order to continue to protect the interests of the community while also facilitating the growth necessary for the city to be able to provide the same quality of service in the future.

One

EARLY YEARS
LAND GRANTS, RANCHOS, AND RANCHES

On March 30, 1840, Spanish governor Juan Alvarado deeded 1,004 acres—which included Brea Canyon and the eastern Walnut Valley—to Jose de la Luz Linares, who founded Rancho Los Nogales (Ranch of the Walnut Trees) on the area where the city of Diamond Bar now sits.

After the death of Linares in 1847, Ricardo Vejar began purchasing portions of the Rancho Los Nogales. By 1857, he had obtained ownership of the entire rancho, thereby increasing his land holdings to more than 13,000 acres and creating one of the most prosperous cattle ranches in the area.

For two decades, the Rancho Los Nogales prospered, but two years of consecutive floods—followed by the great drought in 1863 and 1864—left it in despair after the deaths of nearly all of the ranch's livestock.

Vejar mortgaged his property to two Los Angeles merchants, Isaac Schlesinger and Hyman Tischler, for $600 worth of supplies at an interest rate of eight percent per month. When the note came due at $28,000, Vejar could not repay his loan; in 1864, his property passed to the ownership of the merchants.

Schlesinger and Hyman soon sold the land and everything on it to a young livestock trader named Louis Phillips for a sum of $30,000. Phillips parceled portions of the former ranchos and sold these parcels to new settlers. The dependence on cattle decreased as land that had once been home to grazing cattle was replaced by wheat fields and citrus groves.

As the era of the ranchos came to an end, it paved the way for a new century that would transform the landscape and bring about many changes throughout the next 50 years.

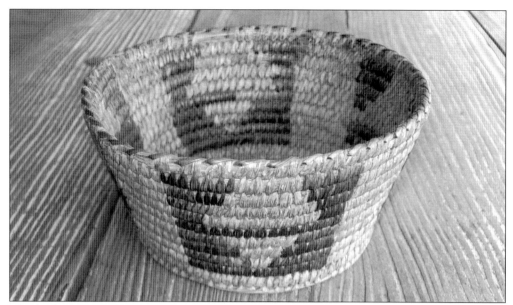

The basket pictured here was woven by the Native Americans who inhabited the Pomona Valley—the Tonga or Gabrielino people, whose village was located in what is now Ganesha Park in Pomona. They were expert weavers who produced baskets woven so tightly they could hold water. The Ricardo Vejar family used these baskets to hold tobacco for rolling cigarettes. (Photograph by Jim Gallivan; courtesy of HSPV.)

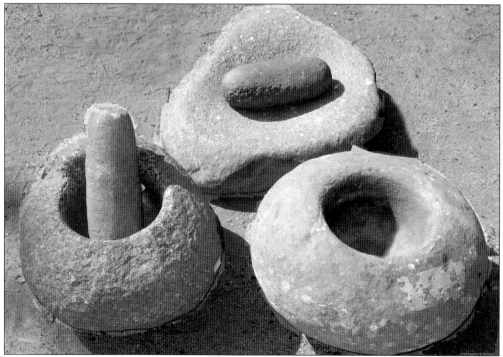

These stone *molcajetes* (traditional Mexican stone tools—commonly referred as to a mortar and pestle—used to crush and grind spices) were used by the natives and belonged to the Ygnacio Palomares family. (Photograph by Jim Gallivan; courtesy of HSPV.)

In 1837, Ricardo Vejar (right) and Ygnacio Palomares were the first California natives to whom the Mexican government granted land in what is now the Pomona Valley area. Upon receiving the 22,000-acre land grant and naming it Rancho San Jose, the two friends and business partners divided the land in half through an informal agreement.

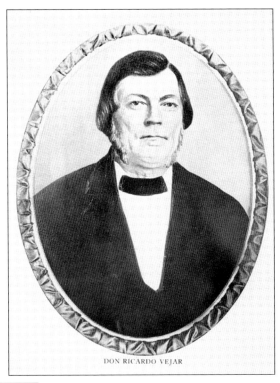
DON RICARDO VEJAR

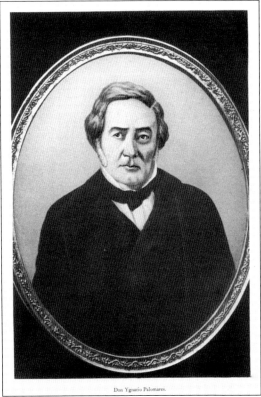
Don Ygnacio Palomares.

Palomares (left) took the northern portion and settled in the area where Pomona is now located, calling it San Jose de Arriba. Vejar occupied the southern portion, or San Jose de Abajo (the area immediately south of present-day Pomona and Brea Canyon). The entire rancho spanned the current sites of the cities of Pomona, Claremont, San Dimas, La Verne, and Glendora.

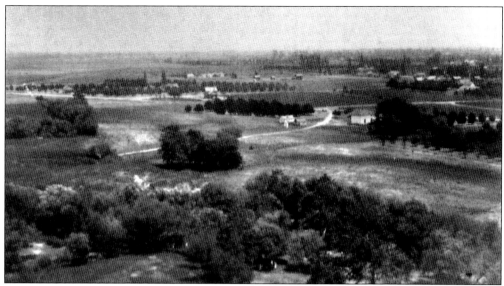
Upon arriving at the Rancho San Jose in 1837 for the first time as its owners, the families of Ricardo Vejar and Ygnacio Palomares gathered under the large oak tree—Padre Oak—at the center of the rancho, with Padre Zalvideo offering a mass of thanksgiving and blessings upon the rancho. Tomas and Madelina Vejar de Palomares built their home just north of the oak tree. (Courtesy of HSPV and James Gallivan.)

The large oak tree known as Padre Oak is believed to have been the stopping place of the mission fathers when they traveled through the area in 1832. It was under this tree on March 19, 1837, that the Palomares and Vejar families held the first Christian religious service in the Pomona Valley. (Courtesy of HSPV and James Gallivan.)

In 1837, Ygnacio Palomares built the first residential dwelling in the Pomona Valley. The adobe house, located on Park Avenue and known as Casa Primera, was home to the Palomares family for 17 years, until they moved to the 13-room Adobe de Palomares located on Arrow Highway in Pomona. (Courtesy of HSPV.)

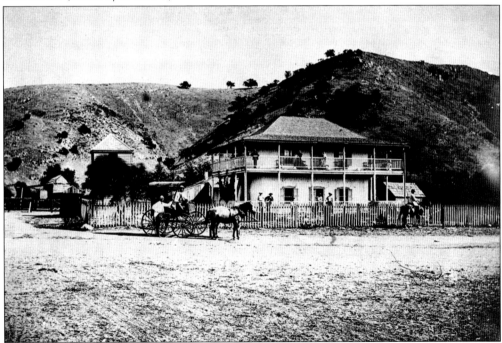

Ricardo Vejar built Casa Vieja de Vejar in 1853. It was the first home Vejar constructed after settling in Rancho San Jose; he subsequently gave it to his son Francisco Vejar in 1857. In 1866, the adobe house became home to Louis Phillips after he had purchased the land, livestock, and residence from the creditors who repossessed the rancho from the Vejar family. (Courtesy of the Pomona Public Library.)

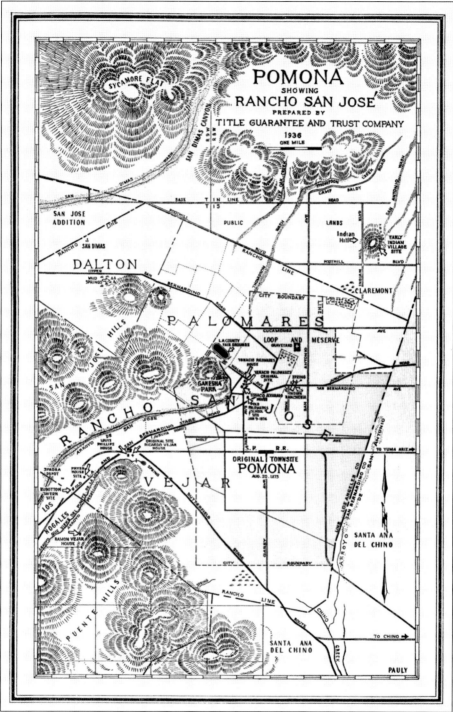

This map shows the 1875 boundaries of the Rancho San Jose, including the Rancho San Jose addition that became part of the original land grant when Ygnacio Palomares's brother-in-law, Luis Arenas, was included in the partnership. In 1844, the Arenas portion of the Rancho San Jose was sold to Henry Dalton of Rancho Azusa de Dalton.

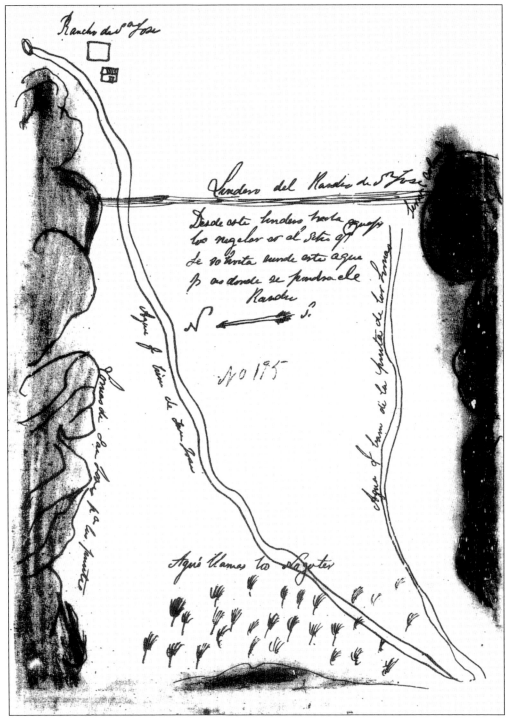

This is the *diseño*, or plat map, of the Rancho Los Nogales. Since land grants were not surveyed, it is impossible to duplicate the exact boundaries of the ranch. Boundaries were often indicated by landmarks on the property, such as large trees, boulders, hills, mountains, or water elements. This 1877 drawing depicts the many walnut trees that influenced the rancho's name.

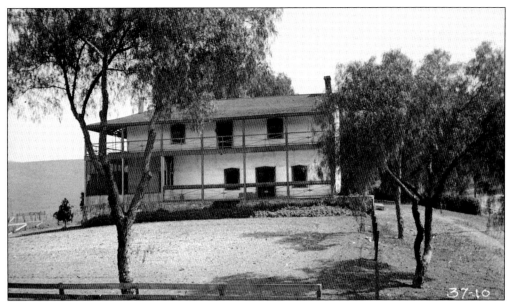

In its heyday, the Rancho Los Nogales was the area's cultural center, meeting place, and home to many celebrations. At the center of it all was Ramon and Teresa Palomares-Vejar's home, one of the most superbly crafted dwellings in the area. Built in 1855 as a wedding gift from Ricardo Vejar, the home measured 34 feet tall by 60 feet long and was surrounded by 8-foot verandas on both floors; needless to say, it was an imposing structure. The exterior adobe walls were two feet thick, made of dark clay loam bound by wheat straw. Most of the timber was sawed and hewn from magnificent ponderosa pines cut high in the San Bernardino Mountains. The porch was constructed of redwood shipped from Northern California to San Pedro. The adobe came from the grounds that are currently home to the Lanterman Developmental Center. (Both, courtesy of the Pomona Public Library.)

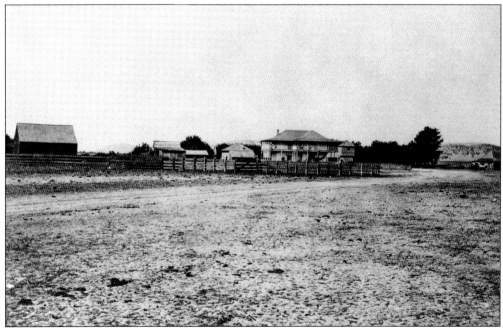

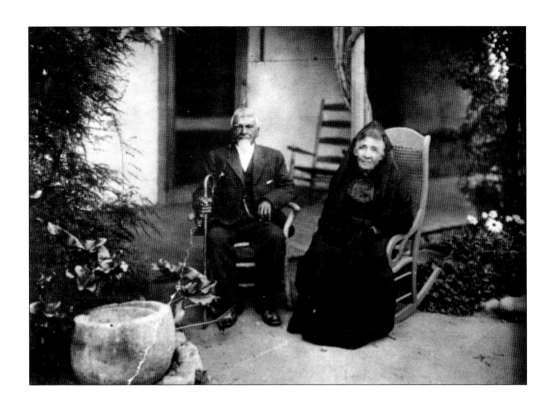

Ramon Vejar is pictured above in 1917 with his wife, Teresa Palomares de Vejar, at their former home on their 62nd wedding anniversary. The photograph below shows their large family gathered for the momentous occasion. (Both, courtesy of the Pomona Public Library.)

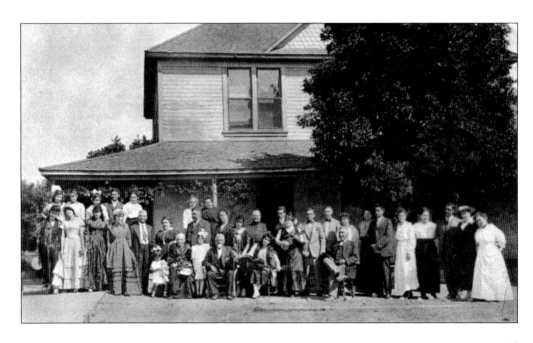

In 1954, poor condition and the expansion of Pacific State Hospital (now the Lanterman Developmental Center) were cited as reasons for the demolition of the adobe structure built by Ricardo Vejar as a wedding gift to his son Ramon. In recognition of the home's significant historical value, the State of California constructed a small-scale model (pictured) near the site of the original homestead. (Courtesy of the Pomona Public Library.)

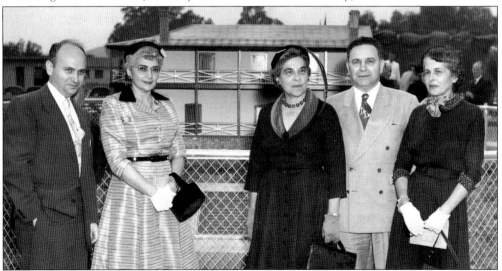

The replica of the Ramon Vejar home was unveiled at Pacific State Hospital in October 1954. Pictured here at the unveiling are, from left to right, Dr. George Tarjan, superintendent of the hospital; Beatrice Vejar de Soto; Viola Vejar de Soto; Walter Rapaport, director of the State Department of Mental Hygiene; and Evalenko Vejar. The women are all descendants of the Vejar family. (Courtesy of the Pomona Public Library.)

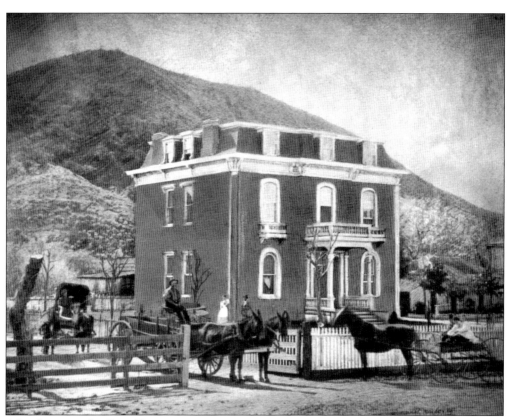

After living in the Casa Vieja de Vejar adobe from 1866 to 1875, owner Louis Phillips built a three-story mansion on the site. The Second Empire structure was the first brick building in the area. The mansion was converted into apartments during World War II. The Historical Society of Pomona Valley purchased the building in 1966 and began restoration, which continues today. The graves of Phillips and his wife, Esther, are in Spadra Cemetery in Pomona. (Both, courtesy of HSPV.)

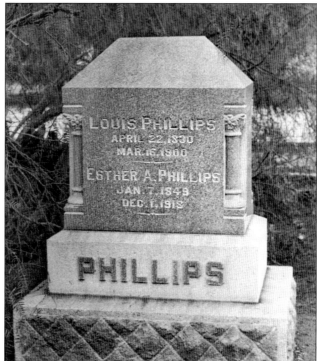

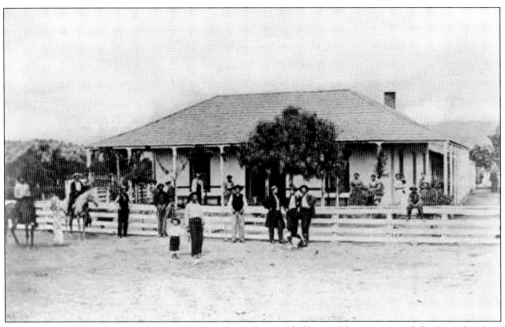

In the town of Spadra, the first settler to whom Louis Phillips sold a portion of the Rancho San Jose was William "Uncle Billy" Rubottom. Soon after, Rubottom opened a hotel and tavern, which became a regular stop for the Butterfield stagecoach. By 1870, the area boasted three stores, two blacksmith shops, warehouses for shopping via the railroad, a school, and a post office. A native of Arkansas, Rubottom named the growing community Spadra after his hometown. While Spadra began as a thriving community, the introduction and expansion of the railroads, along with the incorporation of the city of Pomona in 1888, eventually led to the demise of the town. Above is the Rubottom Tavern, and below are the Caldwell & Brothers General Store and the Spadra post office. (Both, courtesy of the Huntington Library.)

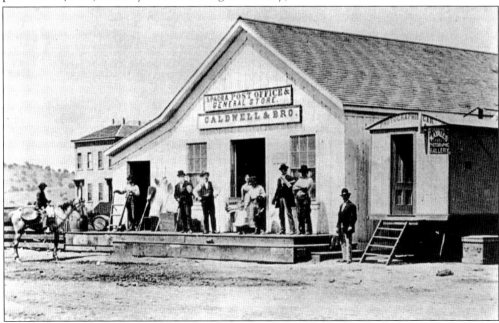

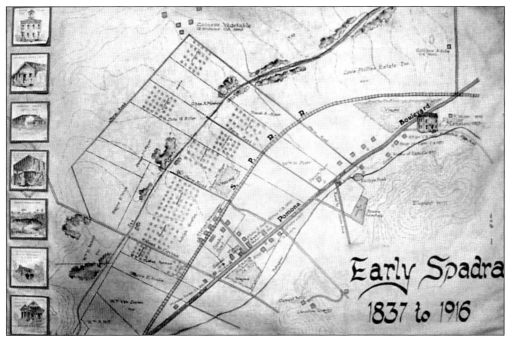

A hand-drawn map of Spadra (above) shows the location of the town's roads and some of the early buildings, including the Rubottom hotel and tavern, the Spadra School (below) that was located on the northeast corner of present-day Pomona Boulevard and Temple Avenue, and the post office that first used the name Spadra on its mail. (Above, courtesy of HSPV and James Gallivan.)

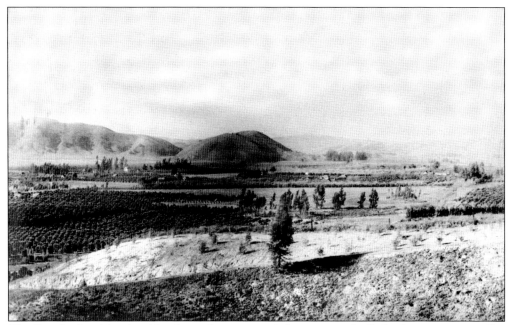

The Rancho Los Nogales, like those that surrounded it, was gradually broken up into smaller parcels, which were sold to many owners. In the mid-1870s, Sedgwick Lynch and Charles M. Wright, who used one of the Vejar homes as a headquarters for the 7,700-acre ranch, owned the bulk of the original land grant, now named Los Nogales Ranch. Wright, who was a veteran stagecoach and wagon train driver, served as manager and reported that the ranch consisted of over 5,000 head of sheep, several hundred cattle, and nearly 100 horses. Grain and alfalfa were planted on the level land around Spadra, the hills of which were used for grazing. After Wright's retirement in 1890, the ranch was divided again and had a series of owners over the next several years.

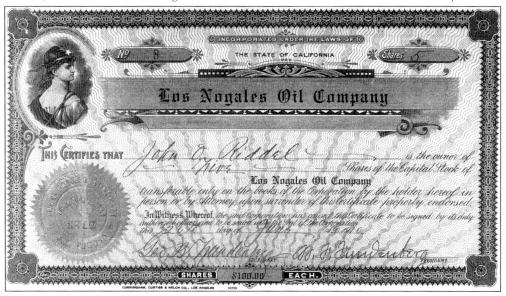

In 1908, Walter F. Fundenberg purchased the former Rancho Los Nogales and transformed it into the Los Nogales Oil Company. Upon this purchase, Fundenberg planned for 500 acres dedicated to citrus groves and the establishment of several oil wells in the southern portion of the ranch.

Two

Diamond Bar Ranch
New Era for Rancho Los Nogales

During a 50-year time span, the modern age made its way into the Walnut Valley, but most of the landscape remained relatively unchanged from the rancho days. In 1918, a New York millionaire named Frederick E. Lewis II came across the former Rancho Los Nogales and purchased 7,800 acres of the land. His first order of business was the construction of corrals, barns, and homes to begin ranch operations. Lewis had the ranch divided into separate areas to house a variety of livestock, with special attention given to a large outdoor pen and farrowing house for Duroc-Jersey hogs.

Within a few years, the hog business was thriving, and the Diamond Bar Ranch had earned a reputation as the breeding site of high-quality champions. In late 1918, Lewis made his initial purchase of 10 Arabian horses. The impact of the Lewis horse-breeding operation was of such significance that even today, bloodlines can still be traced to those original Lewis-bred Arabian horses.

Lewis successfully operated the Diamond Bar Ranch for 25 years, so by 1943, when he sold it to fellow boating enthusiast William A. Bartholomae, president of the Bartholomae Oil Corporation of Fullerton, the once rural property had been transformed into one of the most respected and renowned ranches in Southern California.

The sale of the 7,800-acre Diamond Bar Ranch—for $850,000—was one of the largest land deals to date in Southern California, and it garnered widespread attention due to Bartholomae's prominence as a well-known and respected businessman. Bartholomae spent 13 years overseeing 3,000 purebred Hereford cattle on the ranch.

In 1956, during what was reportedly a tough 15-month negotiation, the Christiana Oil Corporation and the Capital Company (a subsidiary of the Transamerica Corporation) purchased the Diamond Bar Ranch from Bartholomae for $10 million to develop the largest master-planned community in the county of Los Angeles. The first homes, built in 1960 in the northern portion of town, began a construction boom in the area that continued well into the 1980s.

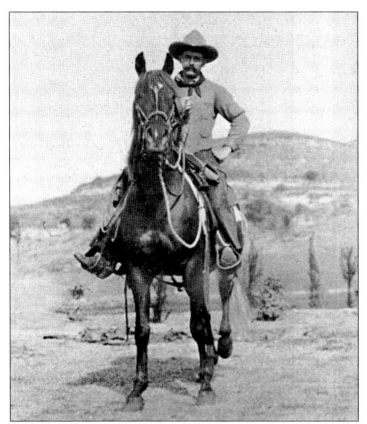

Millionaire New Yorker Frederick E. Lewis (pictured atop prized Arabian horse Harrara) bought the Diamond Bar Ranch in 1918 and transformed the rural property into one of the most respected and renowned ranches in Southern California. According to several sources, Lewis's inspiration for the ranch brand was a quartz mine said to be located near present-day Pantera Park. (Courtesy of C.H. Hopkins.)

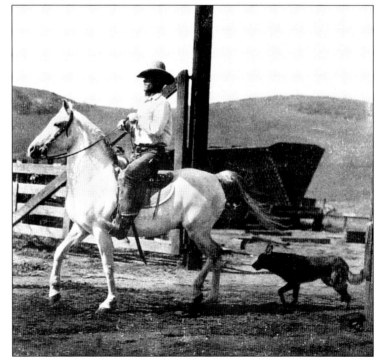

Another prized Arabian and favorite of Lewis was Letan, pictured here with Diamond Bar Ranch foreman John Kitchen. (Courtesy of the W.K. Kellogg Arabian Horse Library.)

The entrance to the Diamond Bar Ranch was lined with pepper trees and located on Brea Canyon Road (now Orange Freeway/Route 57), near the intersection of present-day Diamond Bar Boulevard and Brea Canyon Road. Prior to Lewis's purchase of the 7,800 acres, the land that was once Rancho Los Nogales had been fragmented and sold to multiple owners; his purchase consolidated the original land grant. Above is the ranch entrance as it appeared in the 1950s, and the below photograph shows the location of the entrance today; it is now home to the Peppertree Shopping Center. The men in the below image—Bill Bartholomae (left), son of former owner William A. Bartholomae, and Glennon Neubauer, Diamond Bar Historical Society member—are holding a framed copy of the above photograph. (Above, courtesy of Bill Bartholomae.)

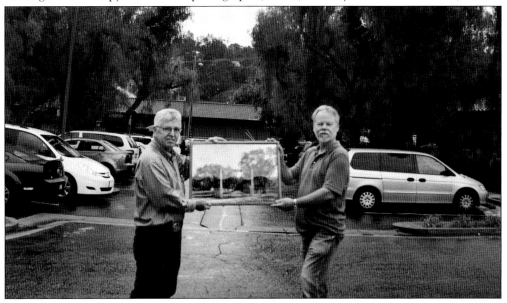

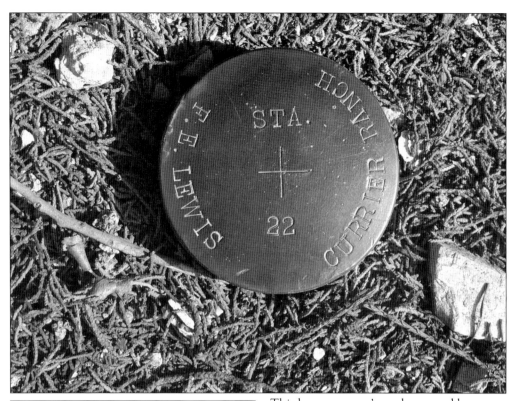

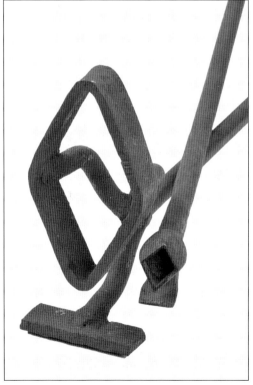

This brass surveyor's marker—used by Frederick E. Lewis, owner of the Diamond Bar Ranch, to identify the boundary lines between his and neighboring properties— was found in the 1980s during construction of the South Pointe development off Brea Canyon Road. The neighbor was the 2,500-acre Currier Ranch, owned by A.T. Currier, who purchased the property in 1869. Currier was elected sheriff of Los Angeles County in 1881 and state senator in 1898.

Soon after purchasing the ranch, Lewis registered the ranch brand Diamond Bar—a diamond over a bar—with the California Department of Agriculture. Branding irons were utilized to brand livestock for easy identification of cattle that might wander to a neighbor's ranch or that were open-range grazed. These brands were used on the Diamond Bar Ranch from 1918 into the 1950s. The large branding iron was donated to the Diamond Bar Historical Society by Diamond Bar resident Robert Gunn. (Photograph by Rausin Photography.)

Upon arriving at the Diamond Bar Ranch in 1918, Frederick E. Lewis commenced construction on the facilities for ranch operation. First was his own residence—a one-story, three-bedroom home with a full-width porch (pictured here from two different angles). It was passed on to the Bartholomae family when William A. Bartholomae purchased the ranch in 1943. The Bartholomaes moved into the home in 1949 and lived on the ranch until 1956. The home was located at the present-day site of the Evangelical Free Church on Diamond Bar Boulevard, just east of Brea Canyon Road. (Both, courtesy of the Evangelical Free Church.)

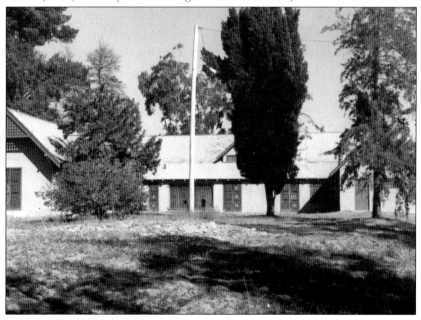

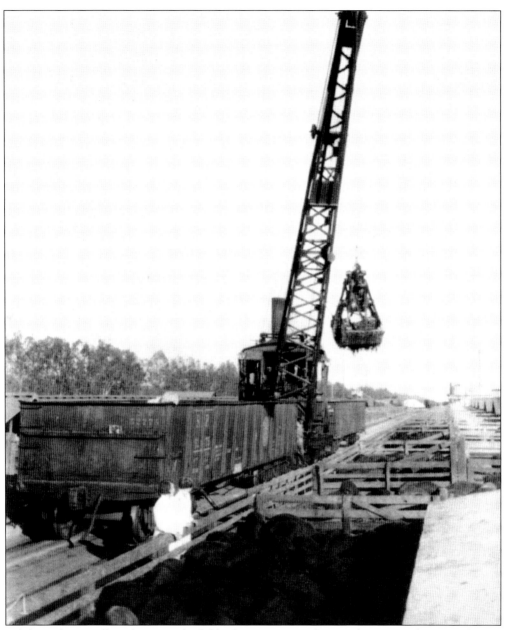

While cattle were allowed to roam the fields, the Duroc-Jersey hogs at the Diamond Bar Ranch were kept in either a large outdoor pen or within a specially designed, 1,200-foot-long farrowing house that could accommodate up to 250 sows and their litters. Shortly after construction of the farrowing house in 1919, the breeding operation quickly increased from 100 to more than 7,500 Duroc-Jersey brood sows; leading the herd was the award-winning prize boar "Ace of Pathfinders."

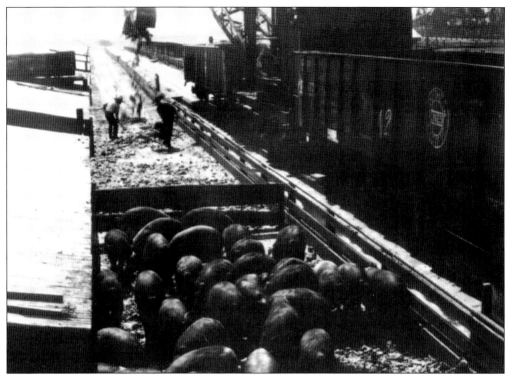

Within a few years of its establishment, Diamond Bar Ranch had earned a reputation as one of the top breeders of high-quality champion hogs in California. The cost of raising hogs on grain in Southern California was not profitable, so in partnership with fellow hog farmer A.B. Miller, of Fontana, Diamond Bar owner Frederick Lewis decided that garbage was a more cost-effective food source. In 1920, Lewis and Miller secured a garbage-hauling contract from the City of Los Angeles for a daily estimated 300 tons at a cost of 60¢ a ton. Soon, more garbage was being hauled than could be consumed, so an additional 35,000 feeder hogs were purchased and kept at Miller's Fontana Farms. Lewis developed an automated system that allowed a crew of two men to feed the thousands of hogs in the same amount of time that it would take 100 men to do so in a conventional manner.

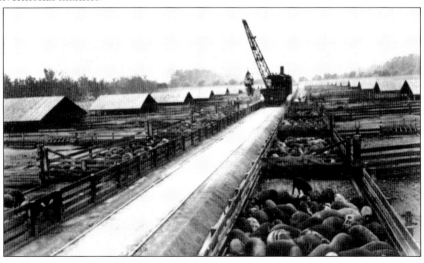

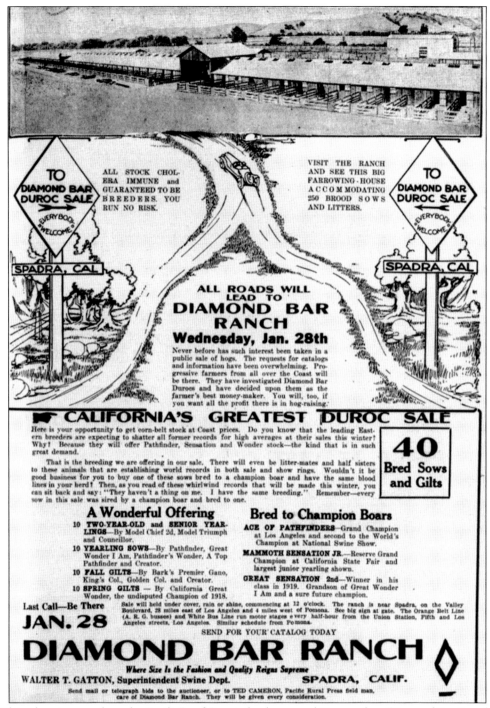

This advertisement from the *Pacific Rural Press* is for the annual Duroc sale at Diamond Bar Ranch. The sale was an opportunity for local farmers to buy Duroc hogs at significantly cheaper prices. These sales would pit dealers from all over California against each other in a buyer's paradise. (Courtesy of the California Digital Newspaper Collection, Center for Bibliographical Studies and Research, University of California, Riverside.)

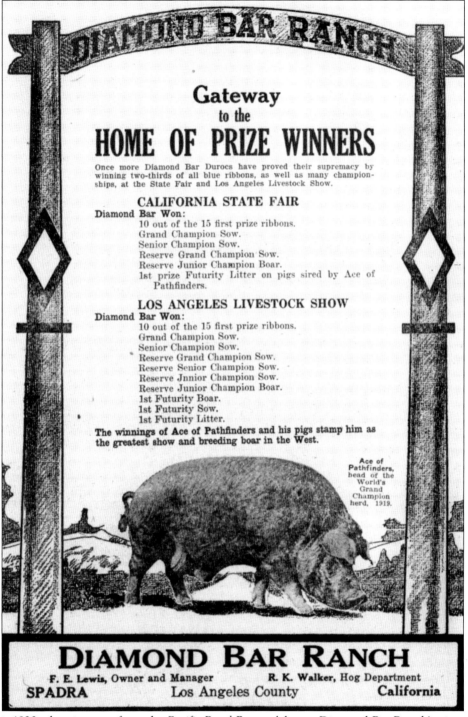

This 1920 advertisement from the *Pacific Rural Press* celebrates Diamond Bar Ranch's victories for best livestock at the California State Fair and the Los Angeles Livestock Show. (Courtesy of the California Digital Newspaper Collection, Center for Bibliographical Studies and Research, University of California, Riverside.)

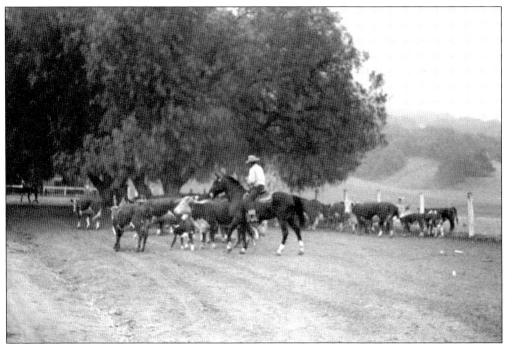

The Los Angeles Livestock Fair closed early due to the influenza pandemic of 1918. The mayor declared a state of emergency, which led to the closure of all local schools and the banning of all public gatherings. Due to the unexpected early closure, many owners were forced to sell livestock quickly and with little negotiation. This worked out in favor of those who had the means to purchase, and because of this unexpected closure, Diamond Bar Ranch owner Frederick E. Lewis was able to acquire seven purebred Hereford bulls. These bulls soon helped grow the herd to 1,500 head of cattle, making the Diamond Bar Ranch a thriving cattle operation. (Both, courtesy of Bill Bartholomae.)

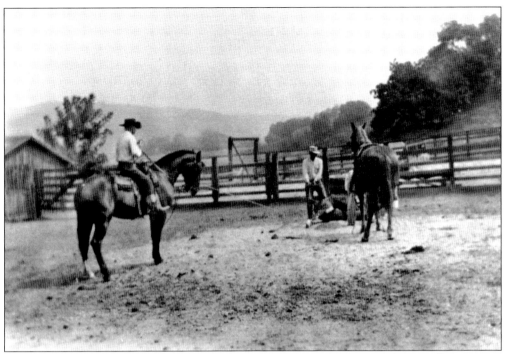

Branding time at the ranch often attracted famous personalities to Diamond Bar. Will Rogers was a great friend of ranch owner Frederick Lewis and his business manager, Christopher "Hoppy" Hopkins. Rogers was said to enjoy roping cattle so much that he would often get lost in the activity and forgo meals. Pictured in these images are ranch manager Ezra Hayes and ranch hands Slim Potter and Earl Pratt. (Both, courtesy of Bill Potter.)

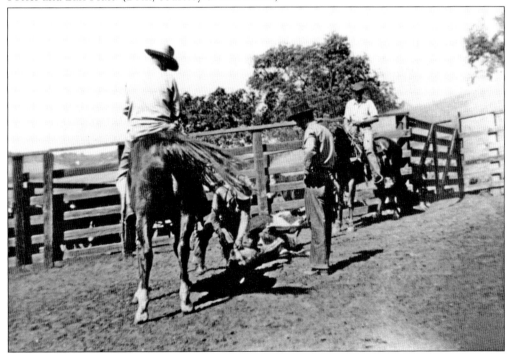

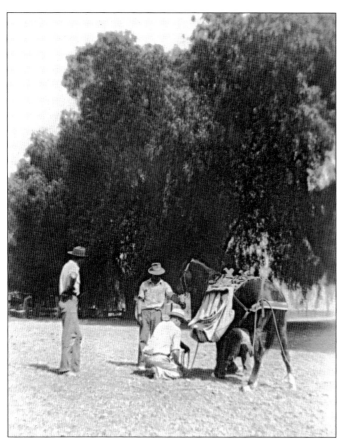

Ranch hands often worked in groups to break the horses at Diamond Bar Ranch. It often took several days to a week to get a horse to a point where it became accustomed to having a bit in its mouth and familiar with the weight and sound of a saddle on its back. (Both, courtesy of Bill Potter.)

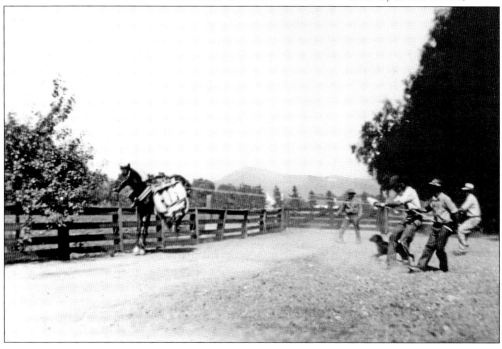

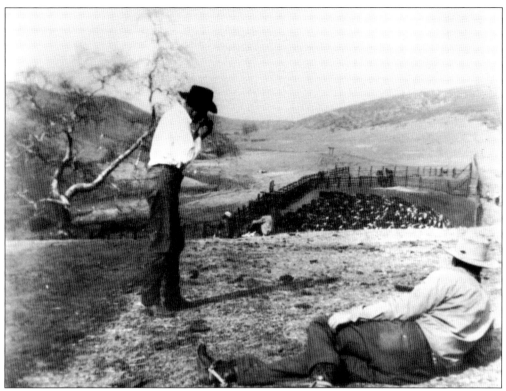
Diamond Bar Ranch manager Ezra Hayes and Bill "Slim" Potter (standing) are taking a lunch break at Fig Tree Corral in this c. 1920 photograph. The corral was located at the present-day site of Sycamore Canyon Park. (Courtesy of Bill Potter.)

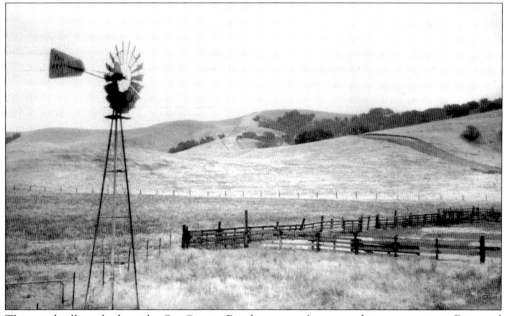
This windmill overlooking the Gas County Road was one of many used to pump water to Diamond Bar Ranch for livestock care and field irrigation. (Courtesy of Bill Bartholomae.)

In addition to livestock, the Diamond Bar Ranch also contained the Lewis Farm, which grew wheat, hay, and alfalfa. In the 1930s and 1940s, the farm's crops were irrigated with reclaimed water from the Tri-City Plant (now called the Pomona Water Reclamation Plant) near the intersection of Humane Way and Mission Boulevard. (Both, courtesy of Bill Bartholomae.)

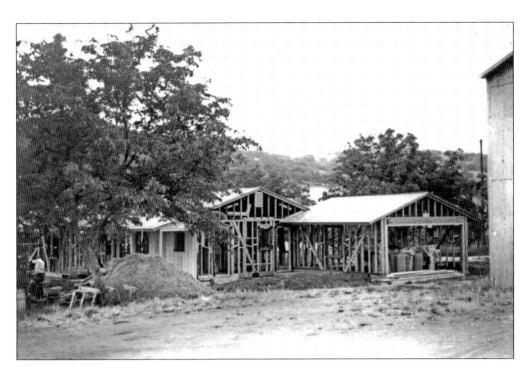

It took a large staff to keep the Diamond Bar Ranch operations running smoothly. The ranch's headquarters were located at the northern edge of the ranch, near present-day Diamond Bar Boulevard and Gentle Springs Lane, and consisted of homes, offices, workshops, and storage buildings. (Both, courtesy of Bill Bartholomae.)

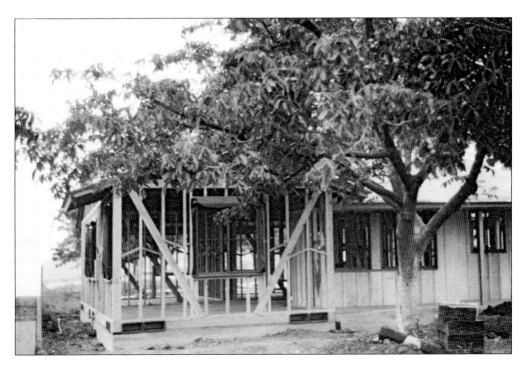

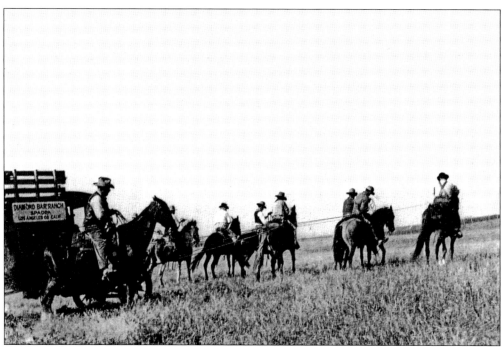

The hilly terrain of the Diamond Bar Ranch often required workers to use horses to navigate the steep grades and pull heavy loads from one area to another. (Courtesy of Andrew G. Brydon.)

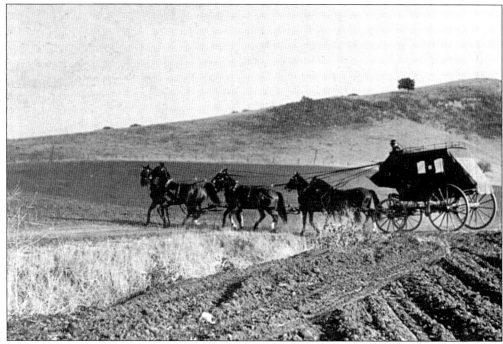

In the 1930s, the area surrounding the Diamond Bar Ranch was home to many other ranches, and taking a shortcut through one ranch to get to another was not uncommon. This image shows William Banning, of the Banning Ranch, taking a ride through Diamond Bar in his prized overland stagecoach. (Courtesy of the Huntington Library.)

In late 1918, Frederick E. Lewis (pictured at right atop Letan, his favorite Arabian workhorse) made his initial purchase of 10 Arabian horses from Hingham Stock Farm in Massachusetts. During nine years on the ranch, 50 registered Davenport Arabians—whose bloodlines could be traced to the Arabian horses originally imported to the United States in 1906—were bred on the Diamond Bar Ranch. (Courtesy of C.H. Hopkins.)

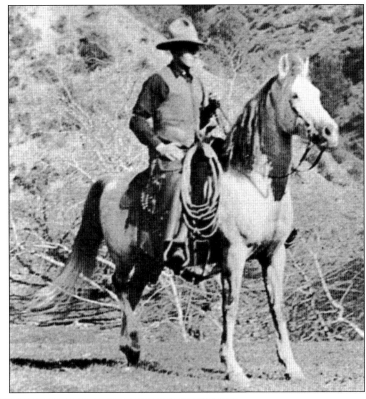

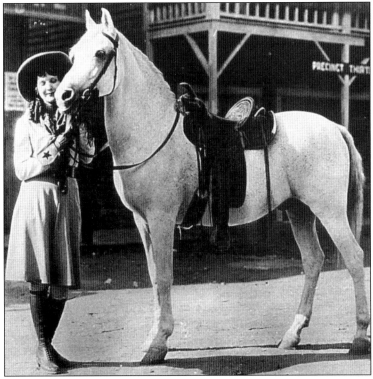

After Lewis sold Letan to W.K. Kellogg, the horse starred in the 1927 film *A Texas Steer*. Letan is pictured on the set with actress Ann Rork, who played the daughter of Will Rogers' character in the film. To safeguard the prized stallion, Kellogg insisted the studio insure Letan for $50,000 and transport him in a specially designed padded compartment trailer with three attendants. (Courtesy of the W.K. Kellogg Arabian Horse Library.)

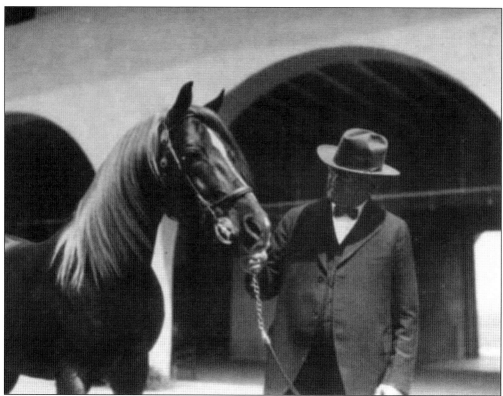

The best-known horse bred by Lewis on the Diamond Bar Ranch was Antez, son of Harrara, who was described as very intelligent, with a beautiful chestnut coat and a flaxen mane and tail. In 1925, Antez was among the horses Lewis sold to W.K. Kellogg for Kellogg's newly established ranch in Pomona. Antez quickly became a favorite of Kellogg's; the horse is pictured above with Kellogg and below in 1928 at the Los Angeles County Fair, where he was named Champion Arabian Stallion. (Both, courtesy of the W.K. Kellogg Arabian Horse Library.)

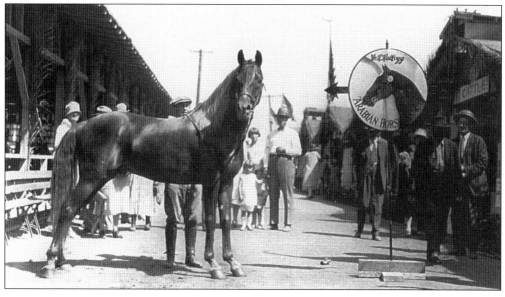

Hasiker (pictured below) was one of the horses that Frederick Lewis sold to W.K. Kellogg. She produced five foals while on the Diamond Bar Ranch and was in foal to Letan when Kellogg bought her. Established in 1925, Kellogg Ranch became well known for both its horse-breeding program and the entertaining weekly horse exhibitions held there. Kellogg deeded his ranch to the state of California in 1949; it is now home to California State Polytechnic University, Pomona. The image at right shows Holly Halstead, the "Rose Queen" of the 1930 Tournament of Roses Parade, with Antez at Kellogg Ranch. (Both, courtesy of the W.K. Kellogg Arabian Horse Library.)

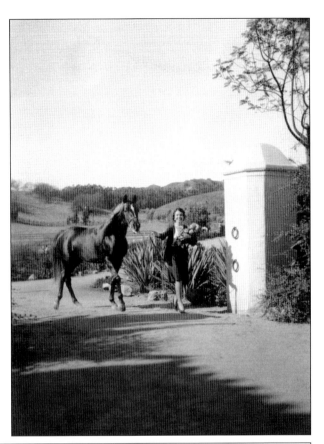

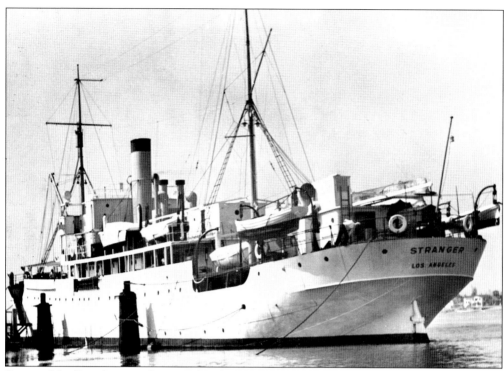

Diamond Bar Ranch owner Capt. Frederick E. Lewis, as he later became known, was an avid sailor who would often embark on faraway exploration trips on his yacht, the *Stranger* (pictured above), bringing back exotic wild specimens that were subsequently donated to area zoos. In 1932, the San Diego Zoo chartered Lewis and the *Stranger* for an expedition to the Arctic; Lewis brought back Kodiak brown bear cubs, "reindeer" (they turned out to be caribou), and a baby walrus (pictured below with an unidentified crew member) that became, at the time, the only one on exhibit in a zoo in the United States. Upon returning from such trips, he would often regale local women's clubs with fascinating tales, along with photographs and, sometimes, the animals themselves. (Both, courtesy of the Quivey family.)

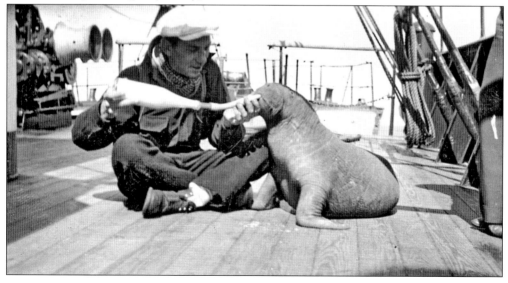

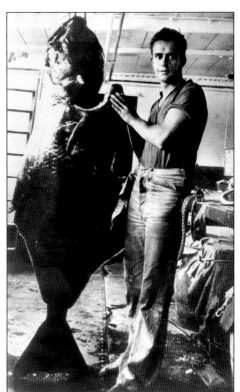

In 1937, Capt. Frederick E. Lewis sailed into Alaskan waters with a crew of trainees, or Sea Scouts, aboard his yacht, the *Stranger*. Pictured at right is Byron Quivey, 18 years old, with a 145-pound halibut caught off the coast of Juneau, Alaska. The photograph below—from that same trip to Alaska—shows a man wearing a prized ivory mask. (Both, courtesy of the Quivey family.)

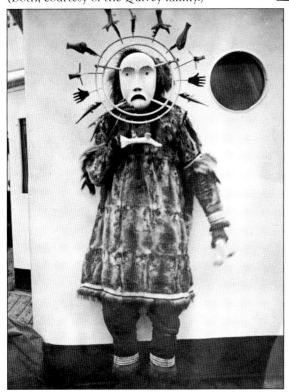

The sale of the Diamond Bar Ranch in 1943 was, at the time, one of the largest land deals in Southern California. For the sum of $850,000, William A. Bartholomae took title of the 7,800 acres (2,000 of which were under cultivation), with the balance consisting of grazing land for 600 head of beef cattle and 12 horses. Bartholomae was not new to ranching; he also owned a large ranch in Nevada and planned to utilize the Diamond Bar for the winter feeding of calves. Pictured below are a few of the ranch buildings utilized as homes for the ranch foremen and, later, as ranch headquarters. (Above, courtesy of Bill Bartholomae.)

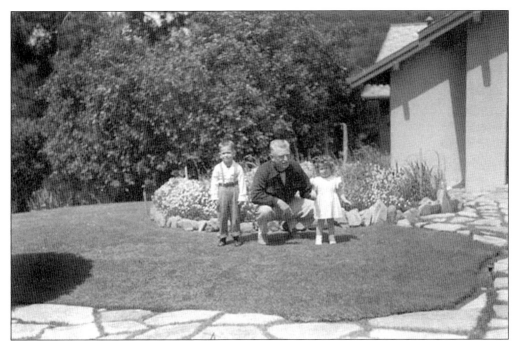

Camp 1, the main house compound at Diamond Bar Ranch, consisted of the family home, corrals, stables, an orchard, a six-car garage, a swimming pool, a guesthouse, and work buildings. These 1951 images show the Bartholomae family in front of the Diamond Bar Ranch residence. Above, William Bartholomae poses with his children Bill Jr. (left) and Sarajane (right); below, William's wife, Sara, stands with their daughter Sarajane. The compound was located on Diamond Bar Boulevard, just east of Brea Canyon Road. (Both, courtesy of Bill Bartholomae.)

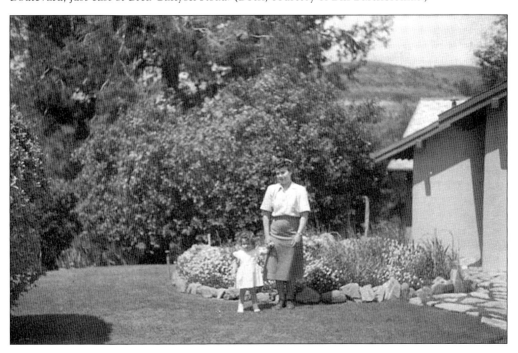

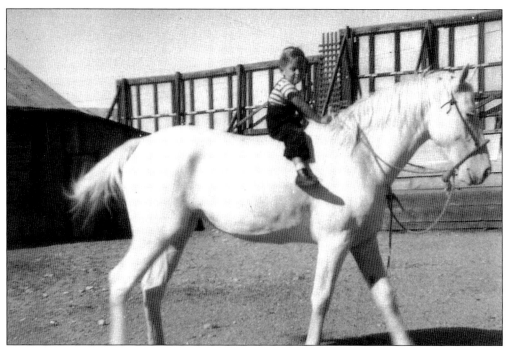

There was always work on the Diamond Bar Ranch, even for the youngest of ranch hands—at age six, Bill Bartholomae Jr. already had a handful of chores. Young Bill is pictured on his white Tennessee walker, Snowball. (Courtesy of Bill Bartholomae.)

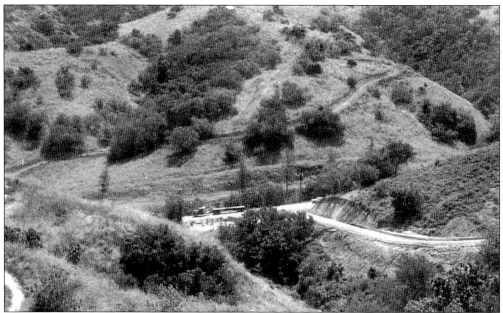

This view from the Camp 1 main house compound overlooks Brea Canyon Road, which heads toward the guesthouse located on present-day Diamond Bar Boulevard, east of Brea Canyon Road. At the time, this was the only paved roadway that led up to the Diamond Bar Ranch from surrounding areas. It remained the primary travel route until construction of the Orange Freeway (Route 57) in 1972. (Courtesy of Bill Bartholomae.)

Prior to purchasing the Diamond Bar Ranch, William A. Bartholomae was already the well-known and respected president of the Bartholomae Oil Corporation. In 1933, he secured a lease from the Stern Realty Company for two dry wells in the East Coyote field near the city of Brea. It was not long before he struck oil and was operating 20 wells there. (Courtesy of Bill Bartholomae.)

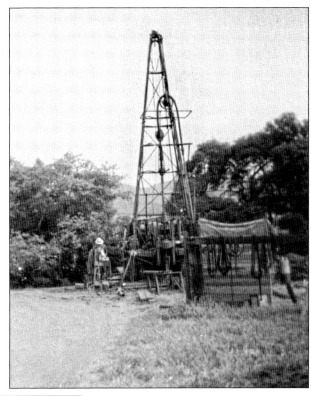

This image is a drawing of the Bartholomae Corporation's headquarters, which were located on Brea Road in Fullerton prior to being relocated to the family's Diamond Hills Estate in 1957. The drawing was featured on a matchbook cover promoting the Bartholomae Corporation, which had interests that included producing crude oil; a gold-mining operation in Teller and Fairbanks, Alaska; beef cattle production at the Bartholomae–Fish Creek Ranch in Eureka, Nevada, and Diamond Bar Ranch; and real estate holdings in California's Los Angeles and Orange Counties. (Courtesy of Bill Bartholomae.)

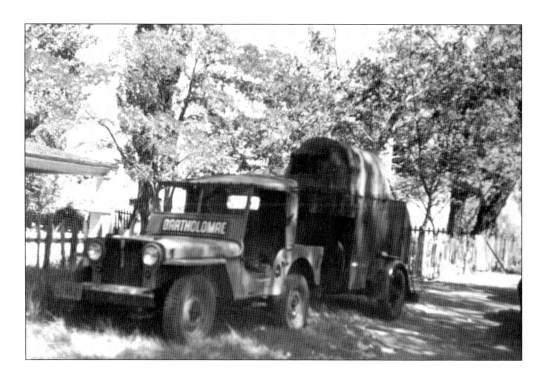

The vast Diamond Bar Ranch was too large to traverse in one day, so it was divided into four areas, each home to a designated camp. This required ranch crews to regularly travel from one camp to another, taking supplies with them. (Both, courtesy of Bill Bartholomae.)

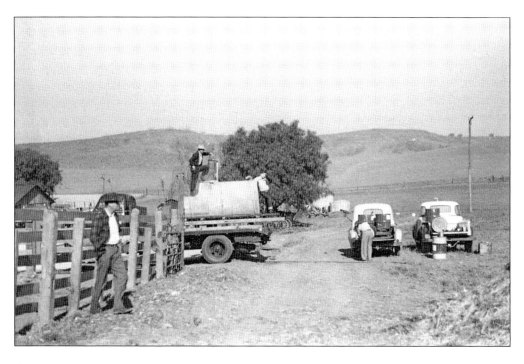

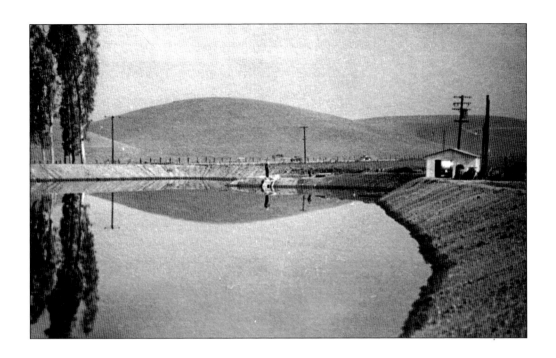

In 1951, a large reservoir and pump house (located at what is now the ninth hole of the Diamond Bar Golf Course) served the water needs of the Diamond Bar Ranch. Local creeks fed the reservoir; today, the creek that flows through Sycamore Canyon Park leads to the water feature of the golf course. (Both, courtesy of Bill Bartholomae.)

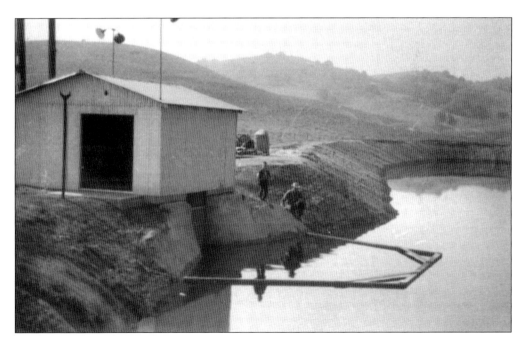

This view looks across the Diamond Bar Ranch from Camp 2, where the horses were corralled. The camp was located near the current intersection of Diamond Bar Boulevard and Pathfinder Road. (Courtesy of Bill Bartholomae.)

This is Camp 2 of the Diamond Bar Ranch, where Bartholomae boarded mares with their foals. The horses were fed and put away for the evening in this sheltered enclosure. During the day, they were allowed to roam within the low-fenced areas. (Courtesy of Bill Bartholomae.)

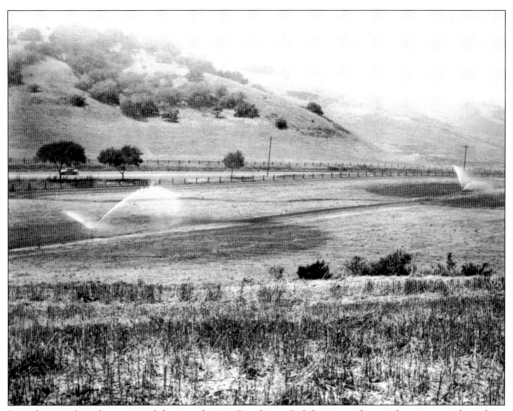

In order to take advantage of the weather in Southern California and provide year-round outdoor grazing, William Bartholomae developed piped-in water irrigation for the grazing pastures. Prior to this addition, the cattle were transported to his ranch in Nevada during the winter. (Courtesy of Bill Bartholomae.)

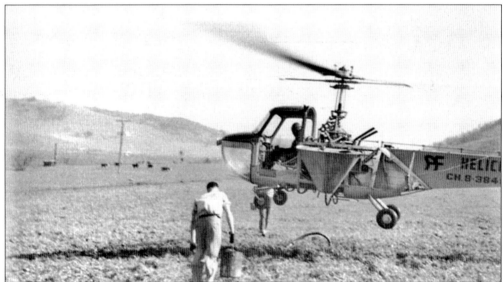

In the 1950s, crop dusting of fertilizer and insecticide solution was often done by smaller, more specialized aircraft. (Courtesy of Bill Bartholomae.)

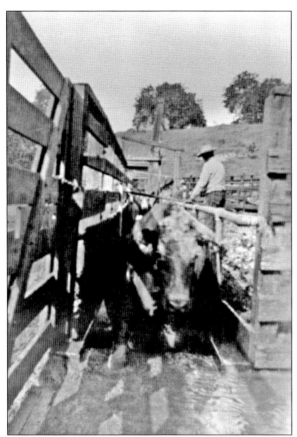

"Dipping" livestock involves herding cattle or sheep through a narrow, deep vat of liquid insecticide to ward off ticks, flies, mites, lice, and other parasites. This trough system enabled ranch workers to treat a greater amount of livestock in a shorter amount of time (as opposed to treating them individually). (Courtesy of Bill Potter.)

Livestock on the Diamond Bar Ranch were often allowed to graze the natural hillsides across the 7,800 acres. Ranch hands would spend days searching watering holes—like the one pictured in this 1951 photograph—along the streams and valleys to locate cattle and ensure they had not wandered off the ranch. (Courtesy of Bill Bartholomae.)

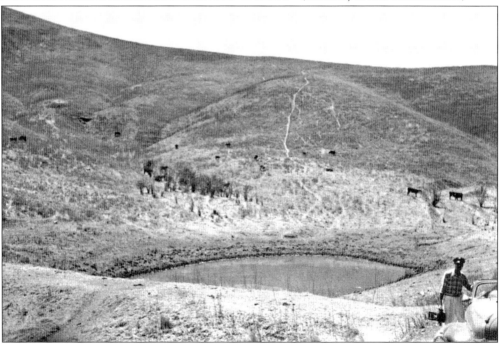

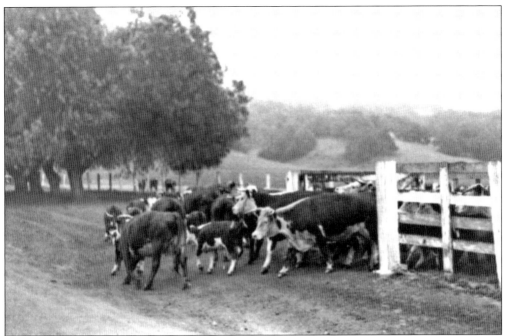

In the 1950s, more than 3,000 purebred Hereford cattle grazed on the Diamond Bar Ranch. Leading the herd was champion bull "Baca Duke" (pictured below), a Hereford that William Bartholomae had purchased for $50,000—significantly more than the cost of a typical suburban home at the time. The below photograph was taken at Camp 4, located in what was known as the community of Spadra, just southwest of the present-day Lanterman Developmental Center. (Both, courtesy of Bill Bartholomae.)

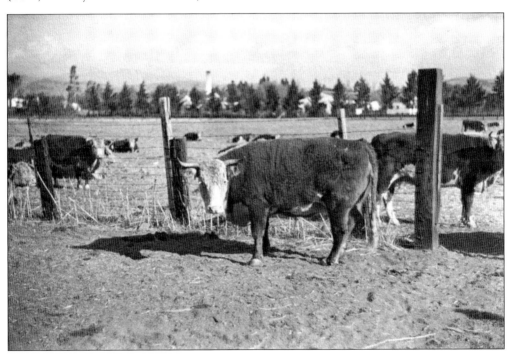

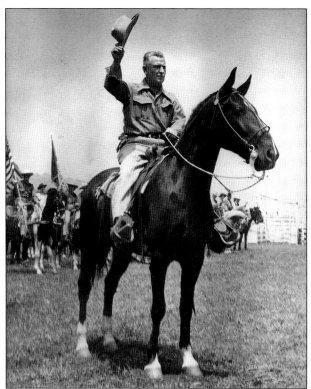

The Diamond Bar Ranch hosted to many events, including an annual rodeo roundup and backcountry horse trail rides. In the image at left, William Bartholomae is leading hundreds of horsemen for a day of traversing the ranch before the commencement of the rodeo and barbecue that was held on present-day Diamond Bar Boulevard between Cold Spring Lane and Fountain Springs Lane.

In 1936, William Bartholomae represented the United States as captain of the Olympic six-meter sailing team in Berlin, Germany. The team, seen here aboard Bartholomae's yacht, the *Mystery*, finished 12th overall. Pictured from right to left are John Wallace, E.S. Dixon, J.O. Livergood, Edward Monohan, and owner and skipper Bartholomae.

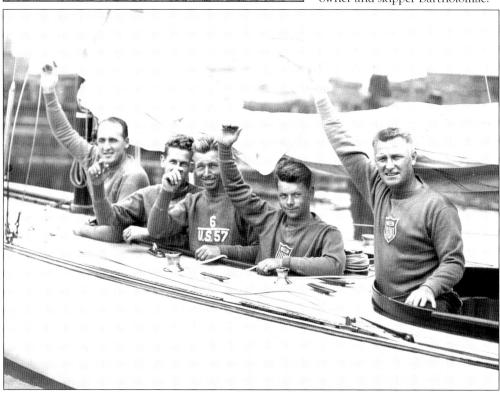

In 1956, William A. Bartholomae sold the Diamond Bar Ranch to the Capital Company, a subsidiary of the Transamerica Corporation and Christiana Oil Company, for $10 million dollars. They purchased the ranch for the development of Los Angeles County's largest master-planned community, which would become today's Diamond Bar. The Christiana Oil Company joined in the purchase to assume control of some of the oil wells that Bartholomae operated throughout southern California; soon after the purchase, the company sold its interest in the ranch to Transamerica. In 1957, Bartholomae constructed a home known as the Diamond Hills estate on a 200-acre parcel near present-day Lemon Avenue and Fifth Street (now Golden Springs Drive). The home was nearly 5,000 square feet and consisted of five bedrooms, six bathrooms, and three garages on a one-acre lot. The family moved into the residence after the sale of the Diamond Bar Ranch and remained there until the mid-1960s. (Both, courtesy of Phyllis Duke.)

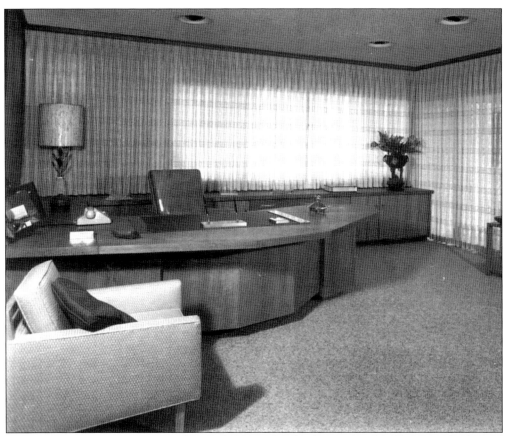

In addition to serving as home to the Bartholomae family, the Diamond Hills estate also housed engineering offices for the Bartholomae Corporation. The home was intended to have been the model for a subdivision tract of luxury estates on the 200-acre parcel, but that plan never materialized. These images show Bartholomae's office, featuring an imported marble fireplace surround and hearth as well as custom teak carpentry. (Both, courtesy of the Huntington Library.)

Three

Transamerica
Blueprint for a Master-Planned Community

The post–World War II era initiated one of the largest development periods in American history, largely supported by the production of manufactured goods and the creation of modern arterial traffic systems. This change in landscape brought about the suburbanization of land extending well into the East San Gabriel Valley.

The Diamond Bar Ranch's hilly topography and remoteness kept it "undiscovered" until these very characteristics grabbed the attention of the Transamerica Corporation. The significant acreage of open land under single ownership and its isolation from other cities but proximity to industrial areas made it an ideal site for a master-planned community. In 1956, during a reported 15-month negotiation, the Capital Company—a real estate and oil development subsidiary of the Transamerica Corporation—purchased the 7,800-acre ranch from William Bartholomae for $10 million.

After adopting the master plan in 1958, the Transamerica Corporation promptly began the installation of utilities and infrastructure, including the development of a potable water network and the formation of the Diamond Bar Water Company. In 1959, under the management of Carleton J. Peterson, a 4,700-foot-long water pipeline was entrenched underneath Diamond Bar Boulevard.

Installation of other primary improvements followed, and once they were in place, the Capital Company began selling parcels of various sizes to select builders while also focusing on the other aspects of the Diamond Bar master plan—roadways, shopping areas, recreational facilities, and educational institutions.

The plan called for a network of roads to emanate from a single highway, as well as a business district at the center of town and two neighborhood shopping centers in outlying areas. To meet recreation and leisure needs, the plan outlined several parks and an 18-hole golf course. Among the educational sites proposed were two high schools, three middle schools, 22 elementary schools, and a private college.

In 1959, when the Diamond Bar Development Company (a Transamerica Corporation subsidiary) took over administration of the property, development was already well underway. However, momentum picked up under this new entity, and commercial, recreational, and residential building activity accelerated considerably. The first planned homes were built in 1960 in the northern part of town; the Transamerica Development Company continued to oversee the development until it sold its remaining real estate holdings in 1986.

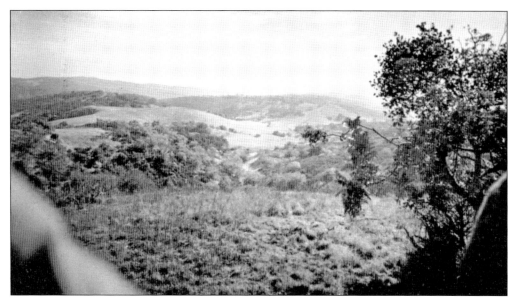

This 1956 image overlooks the natural hillsides of the Diamond Bar Ranch. When the Transamerica Corporation purchased the property from William Bartholomae in 1956 for $10 million, the only structures on the property were the ranch house (which became the first Teen Center and YMCA) and the ranch headquarters (which became the Diamond Bar Water Company's first offices) near the present-day intersection of Diamond Bar Boulevard and Gentle Springs Drive. (Courtesy of Bill Bartholomae.)

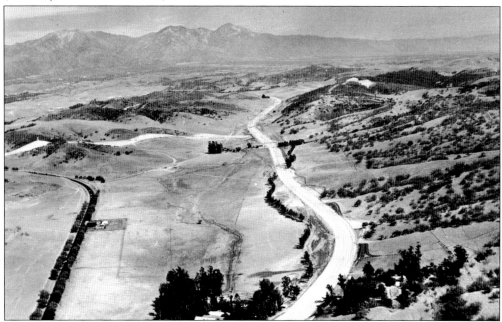

The significant acreage of open land and the fact that Diamond Bar Ranch was isolated from other cities yet surrounded by business and industrial centers made it the ideal setting for a master-planned community. This appeal became the prime marketing tool for the Capital Company to entice potential buyers to leave metropolitan areas for "country living" in Diamond Bar. This aerial photograph offers a view looking north from Brea Canyon Road at Diamond Bar Boulevard.

The Diamond Bar development plan detailed the Transamerica Corporation's vision of creating a 20th-century city, complete with essential elements integrated into a planned community. The plan called for a network of roads to emanate from Diamond Bar Boulevard, a newly created roadway, while Brea Canyon Road was realigned eastward to make way for the Orange Freeway (Route 57), Fifth Avenue was renamed Golden Springs Drive within the city's boundaries, and Pathfinder Road was planned to connect to Grand Avenue but did not due to changes in the development. This 1959 image shows Diamond Bar Boulevard after grading, looking southeast from Golden Springs Drive.

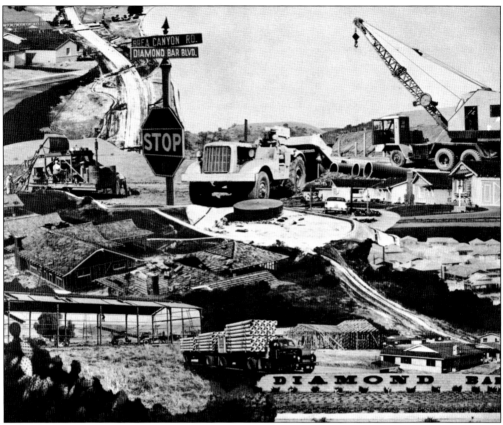

The Los Angeles Regional Planning Commission and Los Angeles Board of Supervisors approved the zoning map for the Diamond Bar master-planned community in 1958 rather than waiting for approval when a development was proposed. Soon after, the Capital Company began selling land to developers with guaranteed water, sewer, and utility infrastructure, as well as roadways constructed by the Capital Company. The above image is the cover from the original Diamond Bar Master Plan document, and the below photograph shows homes located in the northern section of town in the early 1960s.

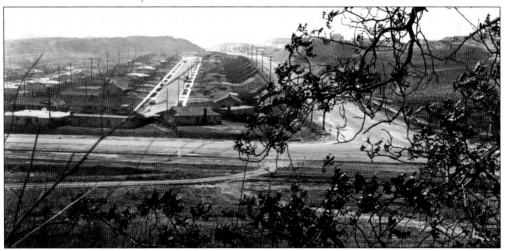

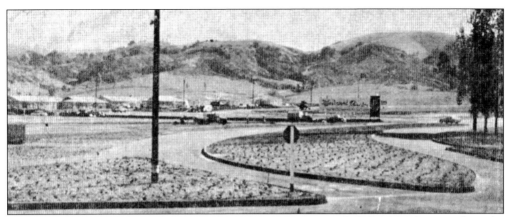

In December 1959, the Southern Counties Gas Company installed the initial service lines for the first 34 homes to be constructed along the first half-mile section of Diamond Bar Boulevard. These lines were part of a $100,000 project to bring gas to an anticipated 3,000 to 5,000 homes constructed in the northern half of the 8,000-acre development over the course of five years.

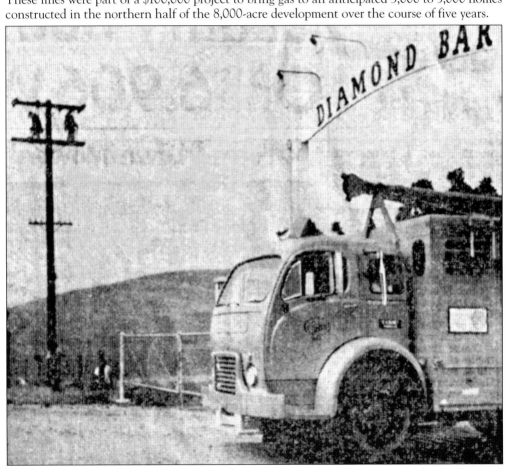

Southern California Edison installed the electricity for the initial 100 acres of the development in 1959. The 12,000-volt line was 100,000 feet long and extended from the Ganesha substation on West Second Street, near the Pomona Convair plant, to Fifth Avenue (now Golden Springs Drive/Diamond Bar Boulevard) and Brea Canyon Cutoff in Brea Canyon.

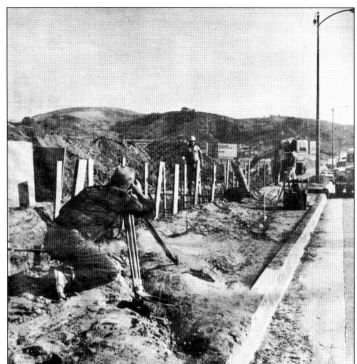

Workers laid the first pavement in the development in 1959. In the image at left, surveyors lay the first curbs along the northern section of Diamond Bar Boulevard. Eventually, the roadway became a 120-foot divided highway that traverses approximately six miles through the center of Diamond Bar.

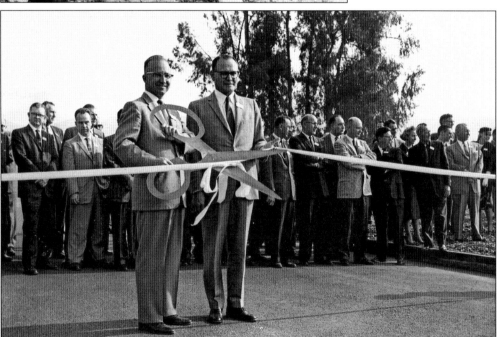

The first roadway created as part of the master plan, Diamond Bar Boulevard, opened in 1960 with much fanfare. This photograph shows Arthur Cox (left), mayor of Pomona, and Paul Allen, vice president of the Capital Company, cutting the ribbon. The city's first streetlights were installed within a few months; at the time, there were about 30 families already living in homes located in the Westwood Ranchos development in the northern area of town.

In 1959, when the Walnut Valley Water District (WVWD) was not in a position to expand its operations to accommodate the new Diamond Bar development, the Capital Company established the Diamond Bar Water Company, a privately owned utility, to facilitate and hasten the delivery of water to Diamond Bar. The newly formed water company invested over $1.75 million in building an ultramodern plant, distribution lines, and a reservoir. The utility—under the management of Carleton J. Peterson, vice president of the Diamond Bar Water Company—dedicated its first water plant in 1961 on Diamond Bar Boulevard. Pictured at right are Paul C. Grow (of the Capital Company) and Peterson (right).

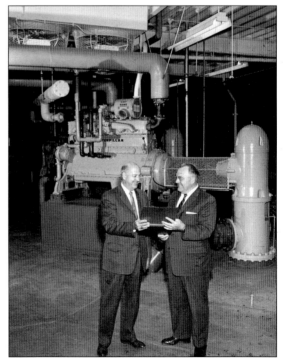

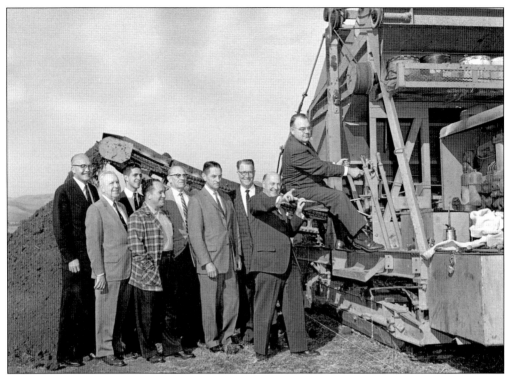

Workers broke ground in 1959 for the North Supply Water Main Project, the development's first water line to service the northern area, which entailed the installation of 4,700 feet of pipeline to join the Metropolitan Water District. Pictured here at the ground-breaking ceremony are, from left to right, George Kendall; Fred Froehde, Pomona Valley Municipal Water District (PVMWD); an unidentified representative of Christiana Oil Corporation; Dr. Jack T. Monroe, Walnut Valley Water District; Carl Lorbeer, chairman of PVMWD; James Patrick, project engineer with Capital Company; John Hibbard, Hood Construction; Paul C. Grow, vice president of Capital Company; and Carleton J. Peterson, vice president of Diamond Bar Water Company.

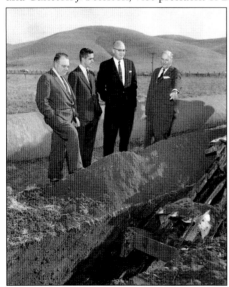

By 1964, primary water distribution lines had been placed throughout the entire community, and a four-million-gallon storage tank had been erected and put into service, establishing a distribution system capable of serving up to 2,000 homes with water for 20 days without pumping a single additional drop, while also providing adequate fire protection for the area. Pictured here at the 1959 ground-breaking ceremony are, from left to right, Diamond Bar Water Company vice president Carleton J. Peterson; an unidentified representative of Christiana Oil Corporation; George Kendall; and Paul C. Grow.

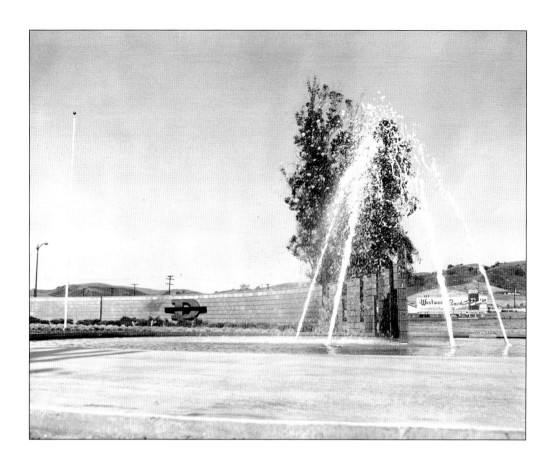

In the 1960s, elaborate landscaped entryways with monument signage and 14-foot water fountains greeted visitors at both the north (Diamond Bar Boulevard) and south (Brea Canyon Road) entrances to the Diamond Bar development. The above image shows the north entrance, and the aerial image below shows the north entrance looking southward from the Pomona Freeway (Route 60). (Below, courtesy of Morris Van Korlaar.)

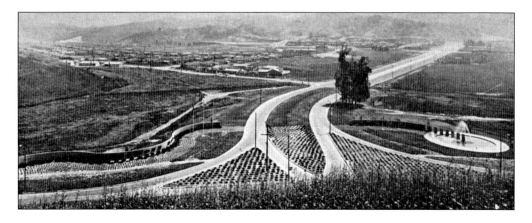

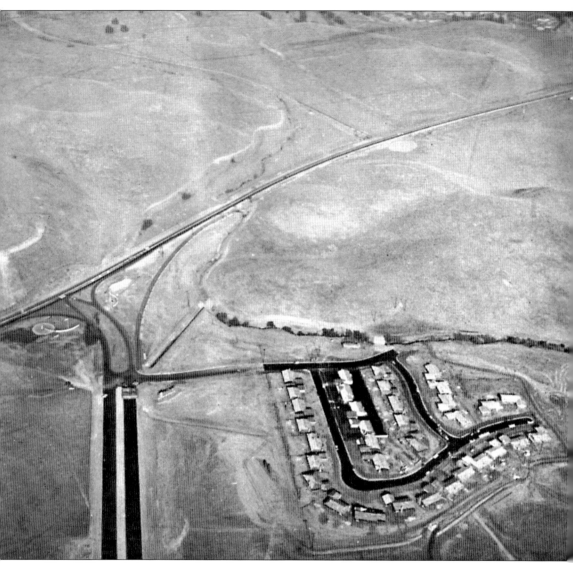

This 1960 aerial photograph shows Diamond Bar's first development, Westwood Ranchos, in the northern section of town. When the 72-acre development was finished, it contained 238 homes. The four-lane roadway to the left of the new homes is part of the first section of Diamond Bar Boulevard. Also at left are a fountain and entry marker built by the Capital Company at the community's northern entrance. The Pacific State Hospital (now Lanterman Developmental Center) is barely visible in the background at right.

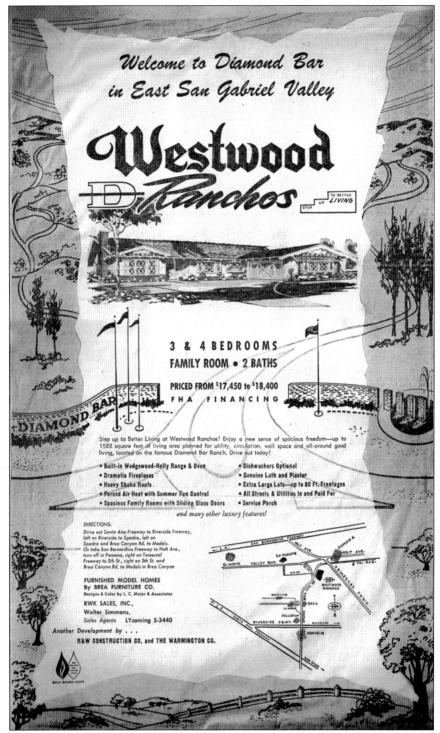

This is an advertisement for the Westwood Ranchos development, where homes were first sold in 1960. Developments like these attracted people to Diamond Bar, and the resulting population boom eventually led to the incorporation of the city of Diamond Bar in 1989.

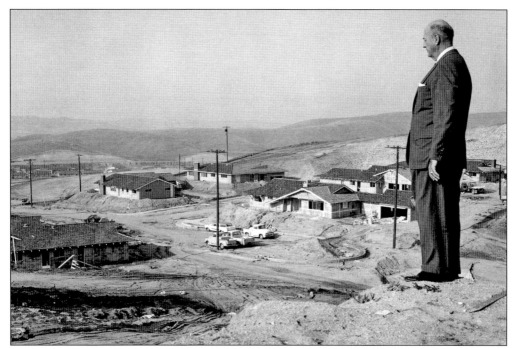

Paul C. Grow, often referred to as the "Father of Diamond Bar," oversaw the development of Diamond Bar for more than 30 years. He began as assistant vice president of the Capital Company, then worked as project manager of the new development. Grow is pictured above overlooking the Golden Springs Estates development in 1960; he and his family lived in the Golden Springs Estates and became the second family to relocate to the new development. Below is a bird's-eye view of construction on the 22-acre Golden Springs Estates development. The three- and four-bedroom homes sat on 10,000-square-foot lots and were priced at or above $25,000. The inclusion of modern, all-electric appliances became a key selling feature of these homes.

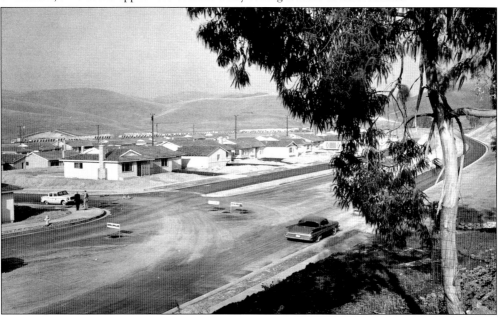

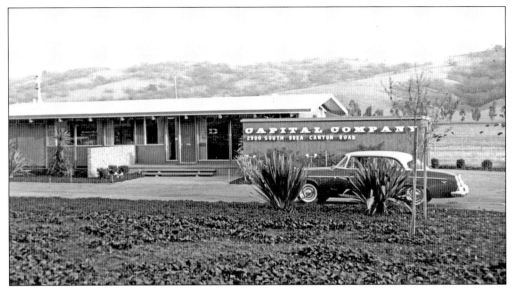

The first offices of the Capital Company were located at 2900 Brea Canyon Road. When the company relocated its headquarters to Grand Avenue, the old building was utilized as a community center, a library, and a meeting place for the Municipal Advisory Council. After Diamond Bar was incorporated, this building was replaced with the city's first facility, the Heritage Park Community Center, in 1993.

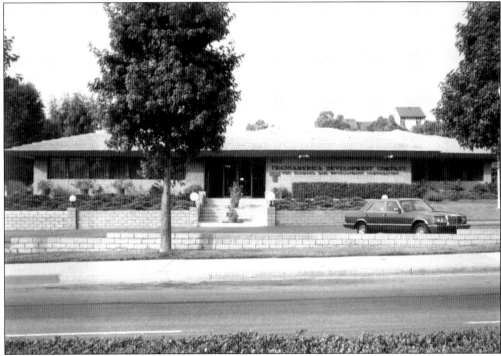

In early 1964, the Transamerica Corporation changed the name of the Capital Company to the Transamerica Development Company, a Transamerica Corporation real estate and oil development subsidiary headed by vice president Paul C. Grow. This 1970s picture shows the renamed company's headquarters on Grand Avenue.

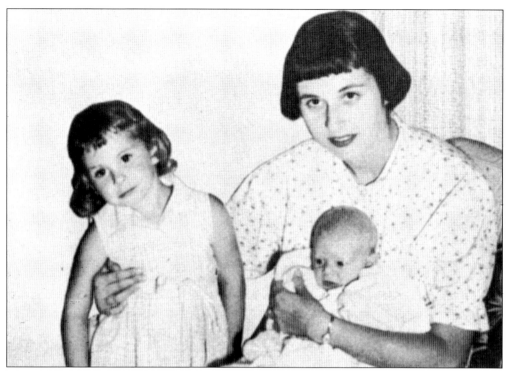

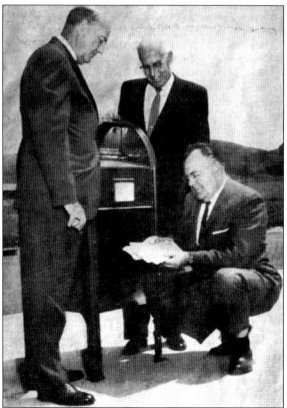

The first baby born in the new Diamond Bar development was Barry Avrum Lank, son of Gerald W. and Dorothy Lank and brother to four-year-old Sharon Lank of the Westwood Ranchos development. Upon his arrival in June 1960, little Barry (pictured above with his mother and sister) was presented with a $100 savings bond from the R&W Construction Company, the Warmington Company developers of Westwood Ranchos, and the Capital Company.

In 1960, Carleton J. Peterson (right) was assigned postmaster of the new Diamond Bar Post Office, located in the Diamond Bar Water Company offices. The first mailbox was located on Palomino Drive at Diamond Bar Boulevard, near the entrance on Brea Canyon Road (now Gentle Springs Lane). Also pictured are Paul C. Grow (left), of the Capital Company, and John Shewman, Pomona postmaster.

Louis and Edna Fortier, the first Diamond Bar residents, moved into their new home on Prospect Valley Drive in April 1960. Pictured here are Louis (center); his nephew Larry Volland (left); and Walter Simmons, real estate broker for the builders. The Fortiers' new home was the first of 34 constructed in the Westwood Ranchos development.

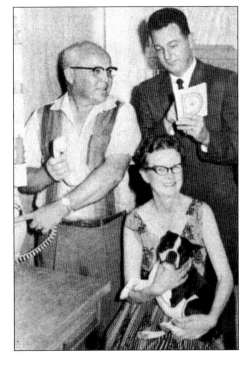

In 1960, the first direct-dial telephones were installed at the home of the community's first residents, Louis and Edna Fortier. All homes built in Diamond Bar were wired in advance for direct-dial telephone service provided by the General Telephone Company of California's new exchange facilities on Valley Boulevard. Pictured here just prior to making Diamond Bar's first direct-dial long-distance call are Louis (left); Bodie Fite, telephone company district manager; and Edna.

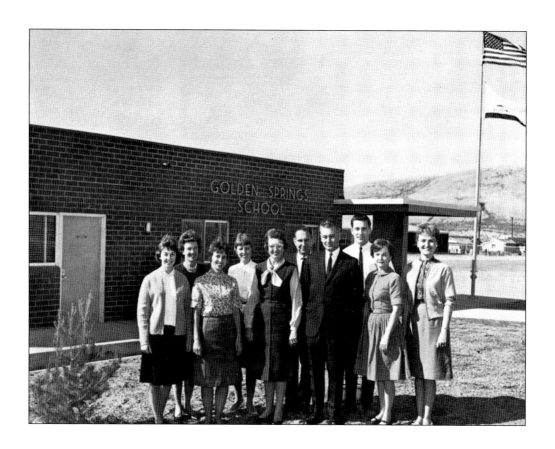

Golden Springs Elementary School, Diamond Bar's first permanent grade school, opened its doors to 278 students in 1963. The 10-acre Pomona Unified School District facility serves the northern third of Diamond Bar. Pictured here are staff members (from left to right) Katherine LeRoy, Marie Schulte, Joyce Parker, Sandra Asper, Lorrayne Clark, W.L. Ellis, school principal Kenneth Cooper, Ted Martin, Frieda Patterson (secretary), and Dorothy Newman. Below is a student assembly.

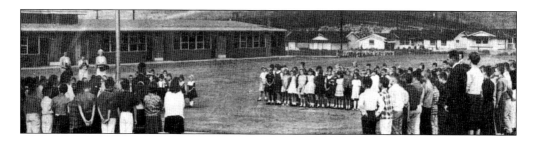

In 1966, Diamond Bar's 20 new home developments offered a wide variety of residences, either on flat lots or hillsides, priced from $19,000 to $36,800. Since the first home was occupied in 1960, the population had grown nine percent—to nearly 9,000. At the time, the national average number of persons per household was 3.3; the average in Diamond Bar was 4.2. Nearly 55 percent of Diamond Bar households had annual incomes of $10,000 or more, and 90 percent of the community's breadwinners were employed in engineering, technical, managerial, professional, or sales positions. This advertisement was used to attract buyers to the development by illustrating Diamond Bar's central location and proximity to many of the recreation areas and attractions in Southern California.

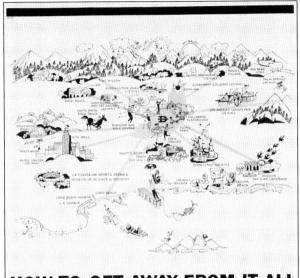

In the late 1960s, just prior to the Pomona Freeway (Route 60) extension through Diamond Bar, the Transamerica Development Company installed this iconic monument signage with a modernized Diamond Bar Ranch logo to let passersby know they were in Diamond Bar. The sign was located at the present-day site of the Ayres Suites Diamond Bar hotel on Golden Springs Drive near Gateway Center Drive. After serving its purpose from the early 1960s to the early 1980s, the sign was removed to make way for development.

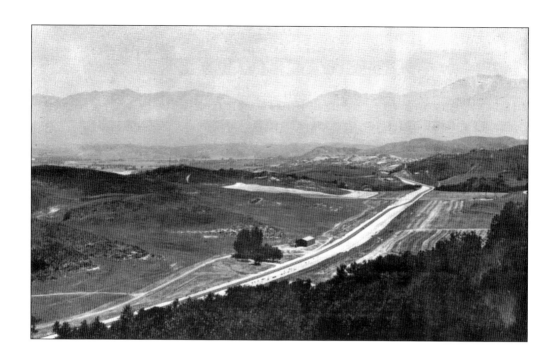

Above is a bird's-eye view of the site for the 200-acre Diamond Bar Town Center, located at Diamond Bar Boulevard and Grand Avenue. In this northward view, Mount Baldy is visible in the background at far right. Below is an artist's rendering of the conceptual plan for the proposed Diamond Bar Town Center development. Due to changing consumer tastes and land-use trends, not all of the proposed facilities were constructed as planned in 1965.

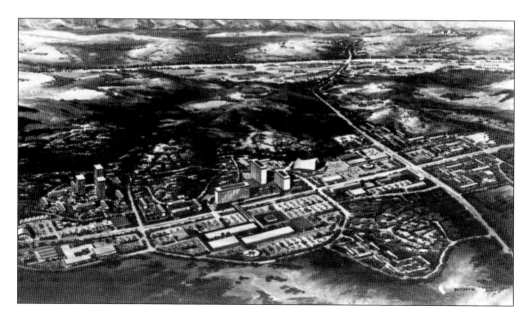

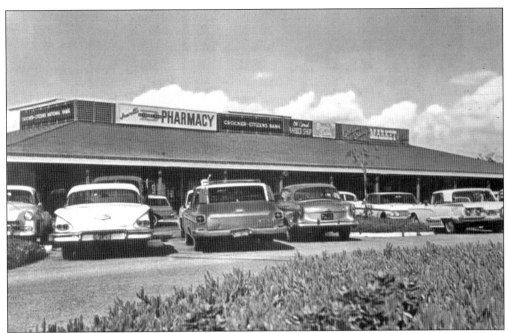

The first commercial businesses in town were located in the Village Square Shopping Center. Opened in 1961, the center offered modern conveniences and was anchored by the 4,500 square-foot Golden Springs Market, Crocker-Citizens Bank, Robert's Hair Creations beauty shop, the OK Corral barbershop, a Sewell's pharmacy, Golden Springs Cleaners, and the Golden Village Mobil service station. The project called for the 11-acre parcel to house additional shops and medical offices. The medical and dental facility, Village Medical Square, was located on Golden Springs Drive and Torito Lane. The Village Square center was located on Golden Springs Drive between Rancheria Road and Diamond Bar Boulevard. (Courtesy of Milan Dragojlovich and Frank Lew.)

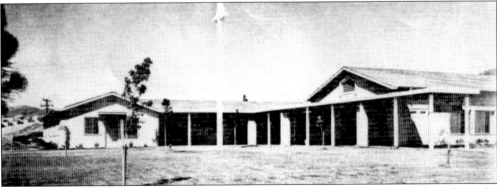

The Northminster Presbyterian Church became the first church to purchase land from the Transamerica Corporation. Once completed, the six-acre site—located at 400 Rancheria Road—consisted of education and worship facilities. Prior to completing the new facility (pictured) in May 1965, the congregation held services in a storefront in the Village Square Shopping Center, which became the city's post office later that year.

LIVE BIG IN

**BIG COUNTRY... ROOM TO ROAM!
BIG OPPORTUNITY... A CIT**

◇ **DIAMOND BAR**... 13 sq. mi. of land for people who want to crowded living and traffic congestion. ◇ **DIAMOND BAR**... 8,000 tiful tree-dotted hills and valleys for those who want to live the ge

◇ **SERVICES HERE AND NOW:** 18 hole Diamond Bar Golf Course-Country Club (both open to the public), Village Square Shopping Center (presently being tripled in size), excellent schools, fine churches, spacious playgrounds, new Little League Field, inviting 14 acre picnic park, Diamond Bar Post Office, a Diamond Bar daily edition newsp munity cle Newly ope Center, in Standard shops. No

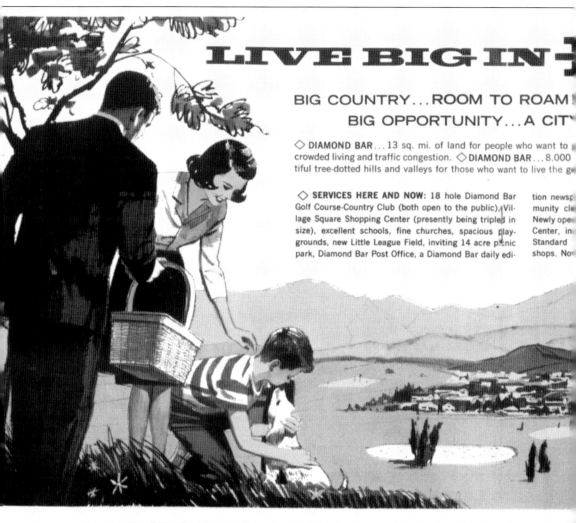

GREATEST 'ONE STOP' HOME SHOW IN SOUTHERN CALIFOR

◇ **WHERE ELSE CAN YOU FIND** 176 distinctive home xteriors?... 47 different floor plans?... 1 or 2 story or olit level Balanced Power or Medallion homes with up to bedrooms, 3½ baths in either beautiful valleys or on ew hillsides?

◇ **NO WHERE BUT IN DIAMOND BAR**, largest masterlanned community in Los Angeles County. Only 9 of the ounty's 76 cities are larger in area than Diamond Bar.

The beauty and spaciousness of Diamond Bar's "Live Big!" country will appeal to you and your entire family.

◇ **OVER 9,000 HAVE ALREADY BOUGHT** in Diamond Bar. We're only 6 years old yet our population already exceeds those of 14 Los Angeles County cities, some of them 40 to 60 years old.

◇ **20 NEW HOME DEVELOPMENTS** dot the north and south sections of Diamond Bar (see subdivision map at

right). 9 o them have been sold out.

◇ **PRICES? PAY AS LITTLE** $36,800 for the home of your

◇ **FOR MORE INFORMATI** ment Company, 2900 S. Brea Calif. 91766. Phones: (213) between 8:30 a.m. and 5 p.

COMMUNITY OF DIAMOND BAR
CALIFORNIA ◇ THE PLACE AND SPACE FOR GRACIOUS LI

A PROJECT OF TRANSAMERICA DEVELOPMENT COMPANY 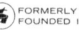 FORMERLY CAPITAL COM
LAND DEVELOPERS FOR 37 YEARS FOUNDED IN 1929

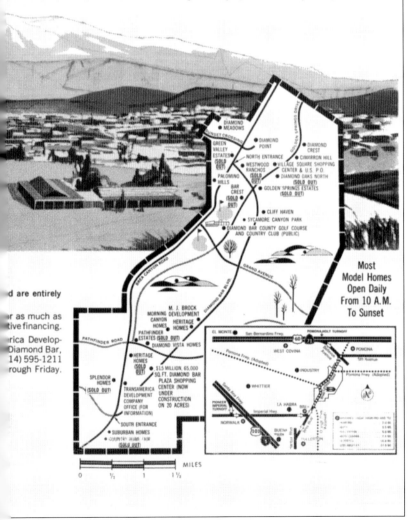

This is an example of advertising used to entice people to move to Diamond Bar. Marketed as a place of tranquility and natural beauty, Diamond Bar became an attractive area for those looking to escape the hustle and bustle of booming Southern California cities.

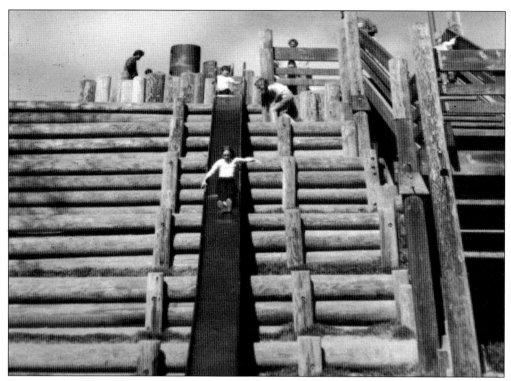

To ensure that the residents of Diamond Bar had space for recreation, the Transamerica Corporation set aside nearly 45 acres of wilderness area for the establishment of the community's first park, Sycamore Canyon Park, which opened in 1962. The recreation area had an abundance of sycamore and live oak trees, a natural creek fed by the San Jose River, and established hiking trails. It could accommodate up to 200 people and 100 cars and was accessible via the access road that started at the intersection of Diamond Bar Boulevard and Golden Springs Road. Pictured above is the one-story-tall log wall that featured a popular metal slide; the wall and slide were removed during remodeling in the 1990s. At far right in the 1962 image below, Sharon McQueen, 7, watches Mrs. Tom Lynch at the grill. Although the entire Sycamore Canyon Park spread across 45 acres, only 14 acres of the park were developed. (Above, courtesy of Jennifer Fox.)

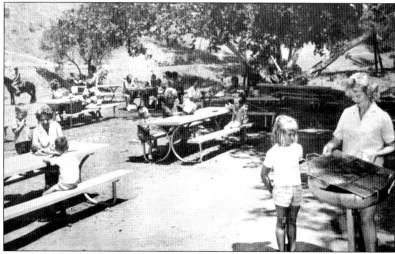

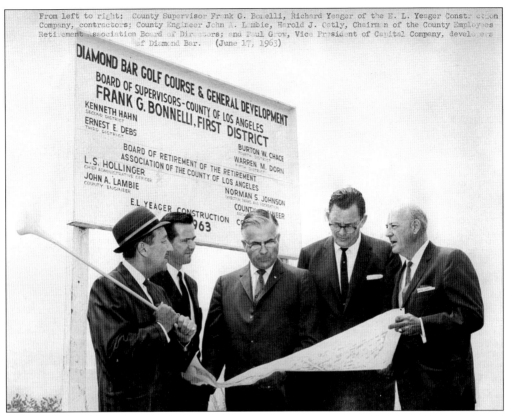

Seeking to create a public golf course, the Transamerica Corporation turned to the Los Angeles County Board of Supervisors for assistance. At the time, Los Angeles County did not have the funds to undertake such a project, so Transamerica leased the land to the county with an option to purchase, and the county's parks and recreation department borrowed money from the county pension fund in 1964. Pictured above on June 17, 1963, are (from left to right) Frank G. Bonelli, county supervisor; Richard Yeager, E.L. Yeager Construction Company (contractors); John A. Lambie, county engineer; Harold J. Ostly, chairman of the County Employees Retirement Association Board of Directors; and Paul C. Grow, vice president of the Capital Company. Designed by William F. Bell, the 174-acre Diamond Bar Country Club and Golf Course cost $1.06 million for the course and $477,955 for the clubhouse facilities. In 1966, greens fees for the 18-hole public course were $3 on weekdays and $3.50 on weekends and holidays.

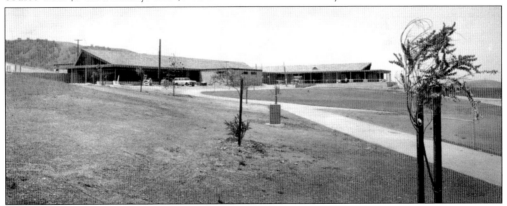

Opened in December 1964, the Diamond Bar Country Club and Golf Course encompassed 174 acres that included a championship 18-hole golf course, a pro shop, and a clubhouse with dining rooms, a coffee shop, and a cocktail lounge. The pro shop offered merchandise to suit the needs of amateurs or professional golfers. The country club became the social center of town. With a seating capacity of nearly 400, it hosted numerous events year-round, with operations overseen by general manager Nick Malooly, pictured at left with employee Ace Shaar (right). Below, a full house was in attendance for dedication day on December 1, 1964.

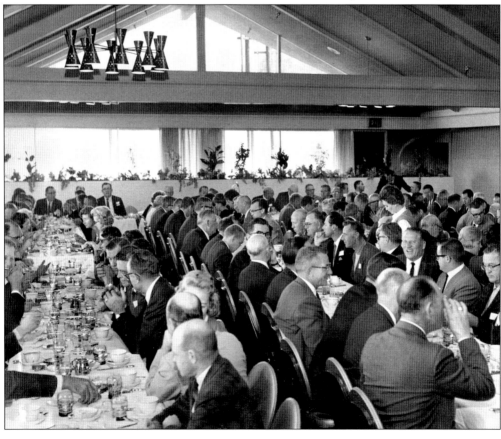

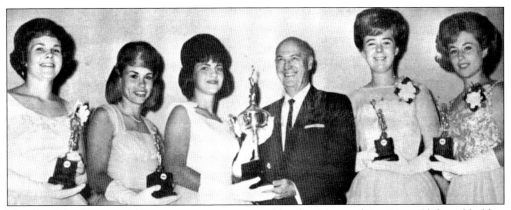

The first Miss Diamond Bar pageant was sponsored by the Diamond Bar Teen Club and held at Castlerock Elementary School in 1964. Pictured here are, from left to right, Barbara Bennett, Cheryl Moyle, Mary Lou Eschrich (Miss Diamond Bar 1964), Paul C. Grow, Dianne Trunnel, and Deborah Barton.

The first years of Diamond Bar saw the beginnings of many community social and sports organizations. By 1964, as many as 50 groups had been formed, including the Diamond Bar Women's Club, which celebrated its 50th anniversary in 2014. In this 1965 image, members of the Diamond Bar Women's Club board are planning a trip to the annual San Gabriel Valley Conference of Women's Clubs in Palm Springs. Pictured here are, from left to right, Mrs. Gordon E. Shaw, first vice president; Mrs. Robert W. Thompson; Mrs. Ralph Risedorph, first vice president–elect; and Eileen Tillery, founder and charter president.

This is a view of the Pomona Freeway (Route 60) from the homes at Diamond Point in the 1970s. (Courtesy of Lloyd James Hedstrom.)

The Hills tract is shown here under construction in 1968; the home in the foreground was located on Acacia Hill Road. (Courtesy of Jennifer Fox.)

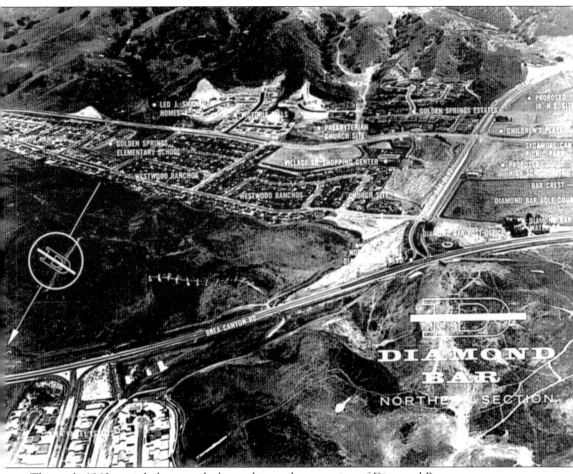
This early 1960s aerial photograph shows the northern section of Diamond Bar.

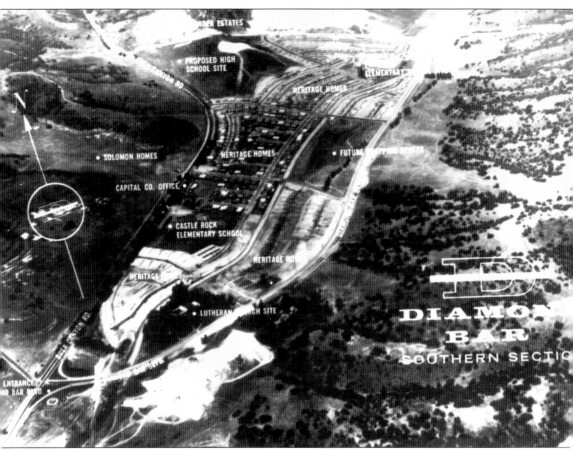

This early 1960s aerial photograph shows the southern section of Diamond Bar.

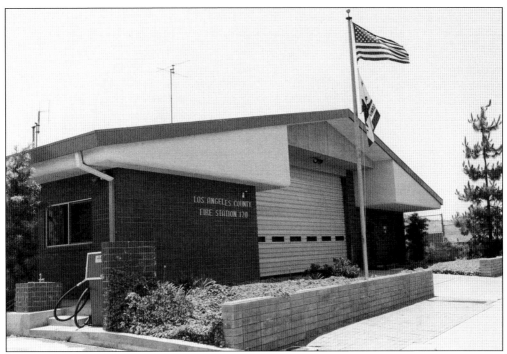

In 1968, the Los Angeles County Fire Department dedicated station No. 120 on Grand Avenue—the first of three stations planned to be located in Diamond Bar. Prior to the opening of this station, fire protection services were provided by Los Angeles County stations No. 60 and No. 91, located in the cities of Industry and Walnut, respectively. In 1981, Diamond Bar received its second station, No. 119, on Pathfinder Road. The 1989 photograph below shows officials at the dedication of the third station, No. 121, on Armitos Place. Pictured below are, from left to right, councilmen John Forbing and Paul Horcher, Los Angeles County supervisor Pete Schabarum, Los Angeles County fire chief P. Michael Freeman, Diamond Bar mayor Phyllis Papen, and Diamond Bar councilman Gary Miller. (Both, courtesy of the Los Angeles County Fire Department.)

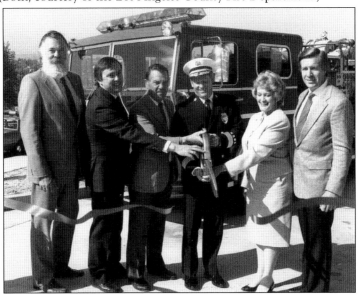

In 1970, development began for the large gated community known as Equestrian Estates; the name was later changed to Country Estates. Overseen by the Transamerica Development Corporation, its custom homesites ranged in size from half an acre to two-and-a-half acres and were priced from $15,000 to $40,000. The 2,400-acre gated community provided scenic lots, private streets, streetlights, underground utilities, equestrian facilities, and permanent riding trails.

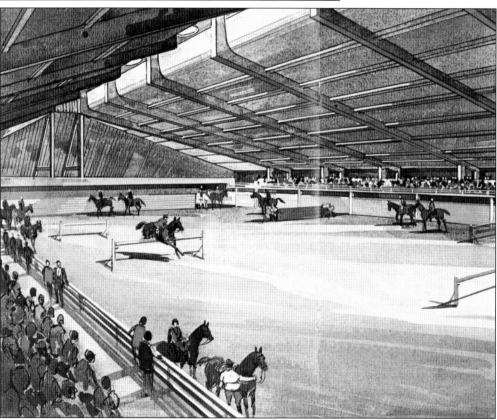

The Country Estates equestrian development included the nation's largest private covered horse show arena, with stables and four outdoor rings; a 150-acre recreation park; a tennis club; and several satellite recreation centers.

In 1965, Diamond Bar opened its own 6,000-square-foot post office in the Village Square Shopping Center, located at Golden Springs Drive at Torito Lane. Prior to this, mail delivery was operated out of the Diamond Bar Water Company offices. Pictured at right are, from left to right, Boy Scout troop 734 member Jim Anderson; Paul. C. Grow, vice president of Transamerica; Diamond Bar's first Eagle Scout, Mike Coleman; Clyde R. Madden, Pomona postmaster; Gene La Chat, assistant to the superintendent; and Albert Olson, acting superintendent.

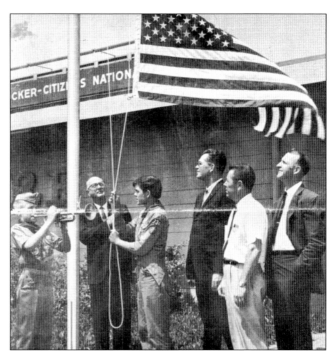

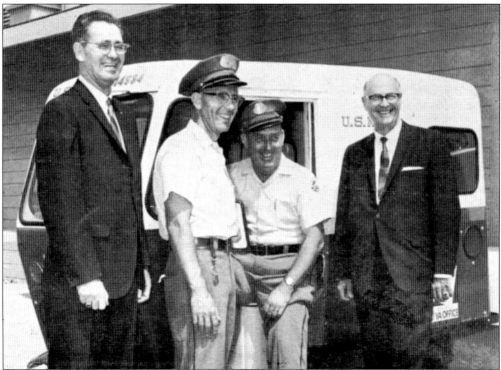

Standing in front of one of four new mail trucks at the 1965 Diamond Bar Post Office opening are, from left to right, Clyde R. Madden, postal carriers Mell Milby and Kelly Stooksbury, and Paul C. Grow. Postal operations remained at the Village Square Shopping Center until a larger, 13,528-square-foot post office was constructed at 1317 S. Diamond Bar Boulevard in 1986.

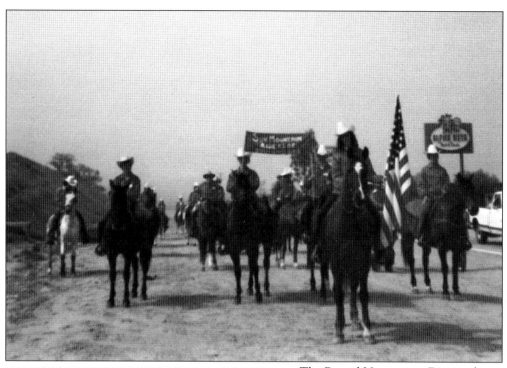

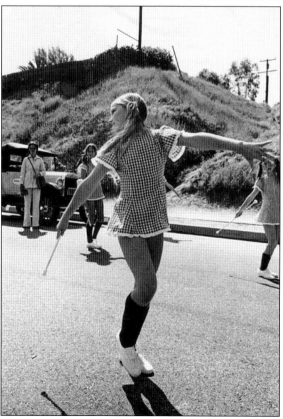

The Round-Up came to Diamond Bar in the early 1970s. The four-day carnival took place at the Village Shopping Center at Diamond Bar Boulevard and Fountain Springs Drive. Sponsored by the Diamond Bar Juniors and Jaycees, the event offered a variety of entertainment, including games, parades, and Western shows. The above image shows a parade heading down Diamond Bar Boulevard in the 1970s, and at left, Amy Hedstrom twirls a baton as part of the 1973 event. (Above, courtesy of Thomas Boyle; left, courtesy of Lloyd James Hedstrom.)

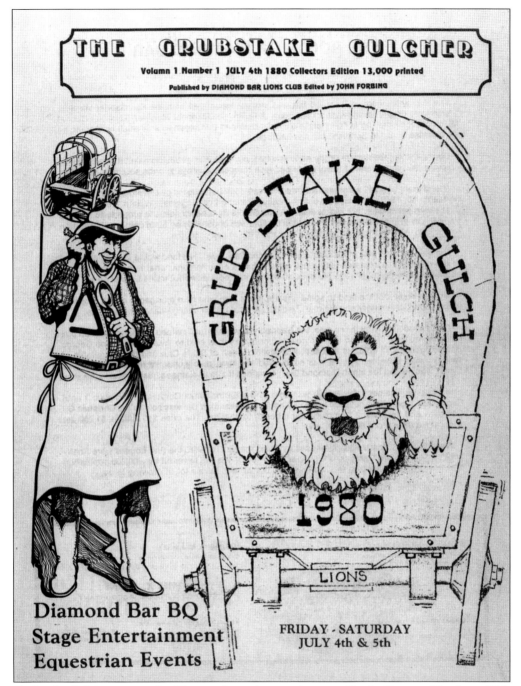

Grubstake Gulch was a popular Western-themed carnival operated by the Diamond Bar Lions Club as a fundraiser. It was held at various locations in town, including the dirt lot that became the site of the post office at Diamond Bar Boulevard and Montefino Avenue in 1986.

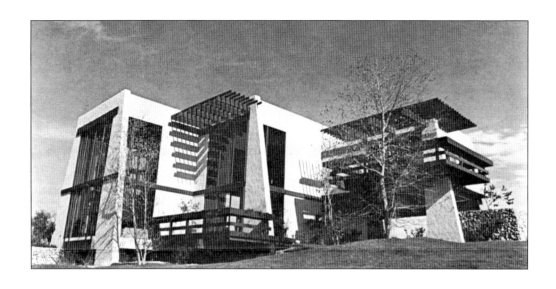

In celebration of California's 200th anniversary, the California Bicentennial Home was constructed in 1970 on a four-acre hilltop site within Diamond Bar's Country Estates. The architecture of the 6,000-square-foot exhibit home combined elements of Spanish-California design and had seven levels of interior elevation, three distinct living areas, an open concept with few walls, and 25-foot ceilings in an atrium that offered sweeping views of the valley. After the bicentennial celebration, the home was sold; it is still located in the Country Estates.

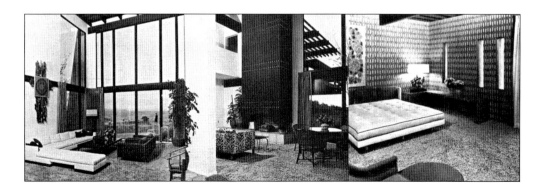

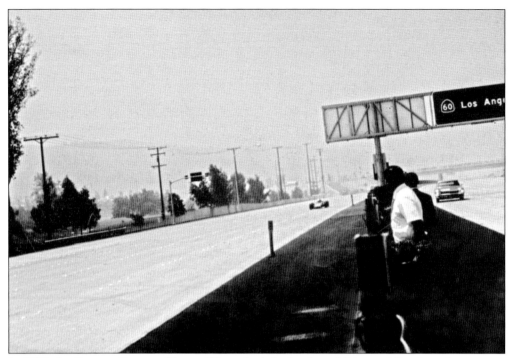

In 1970, the Pomona Freeway (Route 60) reached the borders of Diamond Bar. It took two years and $10 million to complete the 8.5-mile section of the eight-lane freeway, with interchanges at Nogales Road, Water Street, Old Brea Canyon Road, Grand Avenue, and Diamond Bar Boulevard. The new segment extended Route 60 from Fullerton Road in Rowland Heights to its Los Angeles junction at Diamond Bar Boulevard. The dedication, with a parade highlighting California's history, took place on the westbound lanes near Grand Avenue.

The Transamerica Development Company reported a record $11.472 million in residential sales during the first four months of 1975. This figure represented 239 new units sold between January 1 and April 30, 1975. An estimated 40 percent of those buyers were from Orange County, which was attributed to the lower land costs, the opening of the Orange (Route 57) and Pomona (Route 60) Freeways, the family-oriented atmosphere, and the availability of high-quality housing. (Courtesy of Jennifer Fox.)

During the 1960s and 1970s, even though the community's population was growing, and homes were rapidly replacing vacant land, hundreds of sheep could still be seen grazing throughout the community. This image was taken at what is now the intersection of Diamond Bar Boulevard and Grand Avenue.

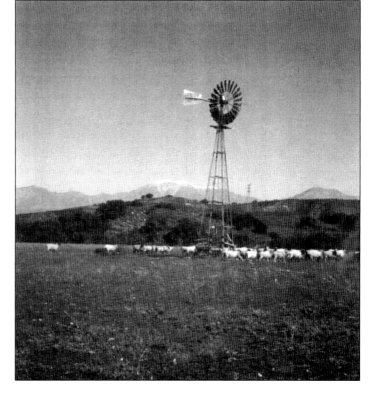

The Diamond Bar branch of the Los Angeles County Public Library, located on Grand Avenue, opened its doors in 1977. The 10,106-square-foot, one-story facility cost $719,000 to build. It featured a large reading room, with separate areas for children and adults, and a multipurpose room. This facility remained in use as a library until 2012, when the library was relocated to the city hall complex within the Gateway Corporate Center. Area library services were first provided by a bookmobile and then, in the early 1960s, operated out of a shopping center storefront on Diamond Bar Boulevard at Fountain Springs Road.

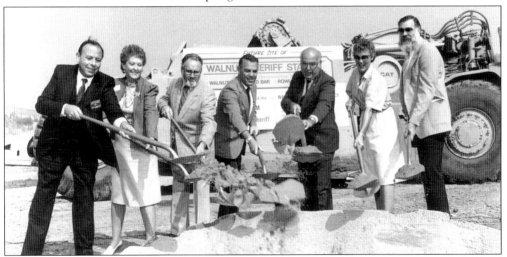

The Walnut Sheriff Station, located at 21795 Valley Boulevard, opened in 1987, with Capt. Thomas Vetter serving as the station commander. The $8 million station was built to serve the growing populations of Walnut, Diamond Bar, and Rowland Heights. Prior to its opening, the Industry Sheriff's Station provided patrols. Pictured here are, from left to right, Don Webster, Lavinia Rowland, Don Stokes, Los Angeles County supervisor Pete Schabarum, Los Angeles County sheriff Sherman Block, Ellen Wyse, and John Forbing.

The Diamond Bar Chamber of Commerce was established in 1983 to serve the growing business community as the prospect of incorporation shifted residents' focus to local issues. A total of 15 board members were elected to varying terms of one to three years. The newly installed officers pictured above are, from left to right, (first row) Sandi Barry, chamber president Gordon Vihlen, and Gwen Henry; (second row) Ted Spandau, Jim Byrne, and Don Stokes. Pictured below are the directors, from left to right, (first row) Mary Ann Dunn, Jess Lynch, Anne Buck, and Bill Tyler; (second row) Fred Sanchez, Gerry Zunino, Carleton Peterson, Chuck Hernandez, and Craig Ammon.

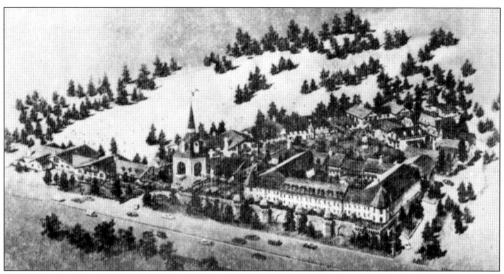

In 1977, a ski resort was proposed for Diamond Bar. The Swiss-Austrian–themed village and ski slope (with artificial snow) would have been located on 29 acres just north of Cold Spring Lane on Diamond Bar Boulevard, adjacent to Country Estates. The plan called for a ski slope and chairlift, a water slide, and a toboggan slide, plus restaurants, a movie theater, sport shops, an amusement center, and a 188-unit hotel and parking garage. Due to land-use issues and concerns from residents regarding traffic, noise, and crime, the project never moved past the proposal stage.

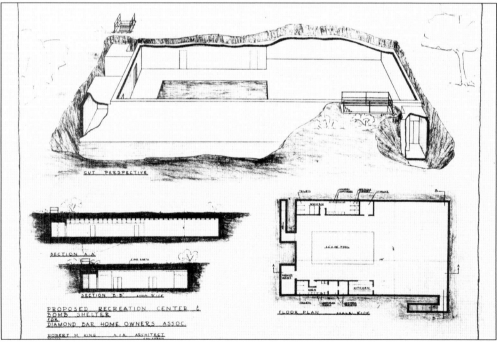

A combination community bomb shelter and recreation facility came under consideration in 1960. The proposed shelter was to be located 15 feet underground and featured a swimming pool and a recreational area. In the event of a nuclear attack, the shelter was intended to sustain 200 people with filtered water from the pool for over a month. The facility was never built due to a lack of community support.

In the early 1960s, the precursor to the YMCA was the Teen Club, which held meetings in a facility donated by the Transamerica Corporation that once housed the Diamond Bar Water Company offices on Brea Canyon Road (near present-day Gentle Springs Drive). The Teen Club eventually became the city's first YMCA. In the early 1980s, the Diamond Bar–Walnut YMCA received land donated by the Transamerica Development Corporation to build a modern, two-story facility on Sunset Crossing Road. Pictured below are, from left to right, (first row) Lois Vihlen, Gordon Vihlen, Gwen Henry, Bill Tyler, Don Stokes, and unidentified; (second row) Gerald Zunino, John Forbing, unidentified, Paul Horcher, and Dan Buffington.

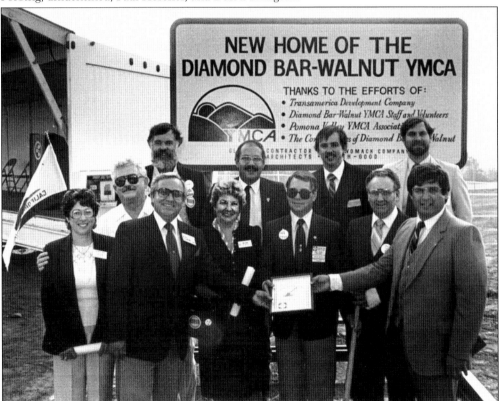

Prior to the 1983 opening of Diamond Bar High School (above) by the Walnut Valley Unified School District, students attended several schools outside the district, including Ganesha, Nogales, and Walnut High Schools. The Pomona Unified School District opened its first high school in town, Diamond Ranch High School (below), in 2000.

The Diamond Bar development was in the planning stages at the same time as the Orange Freeway (Route 57), so the project relocated a few tracts so as to minimize the number of homes that would be impacted by the new freeway. Opened in 1972, the highway spanned 4.5 miles along the former Brea Canyon Road through Diamond Bar. The above image shows Brea Canyon Road in the 1970s, and below is an aerial view of the Grand Avenue interchange in the early 1970s. (Below, courtesy of the Pomona Public Library.)

Four

Road to Incorporation
New Beginnings

Early Diamond Bar residents wasted no time establishing the area's first homeowners' association. By way of a single meeting in October 1960, a small group of property owners created the Diamond Bar Homeowners' Association (DBHOA). As Diamond Bar's population grew, however, so did the desire for local control, community identity, and a formal voice. While the idea of self-governance was often contemplated, the same conclusion was reached every time: the community did not have, and possibly never would have, a sufficient tax base to enable incorporation.

So, in 1976, as a compromise, the Diamond Bar Municipal Advisory Council (MAC) became the first of its kind in Los Angeles County. Within only a few months of operation, Diamond Bar residents had largely embraced the MAC concept because of its role as a community watchdog and assistance with such areas as traffic regulation, safety, parks and recreation, and zoning.

When the 1980s arrived and brought with them a jump in population of more than 50 percent, issues multiplied with the realization that the possibility of Diamond Bar becoming a city was getting closer.

There were, however, opponents to incorporation, which included some MAC members who cited that incorporation was economically infeasible and that little would be gained in public services not already provided Los Angeles County. Only 230 votes defeated the incorporation effort of 1983, largely due to voters' fears about increased taxes.

The debate over incorporation came to a conclusion on March 7, 1989, when voters overwhelmingly approved an incorporation measure 76 percent to 24 percent, securing Diamond Bar the 86th spot on the register of Los Angeles County cities.

When casting votes for or against incorporation, residents also voted to select council members in case the incorporation was approved. The top vote-getter was designated mayor, and the second-highest vote getter was designated mayor pro tem. The third-, fourth- and fifth-place vote-getters made up the rest of the city council.

Phyllis Papen and Paul Horcher won election as mayor and mayor pro tem, respectively. Rounding out the council were Gary Miller, Gary Werner, and John Forbing.

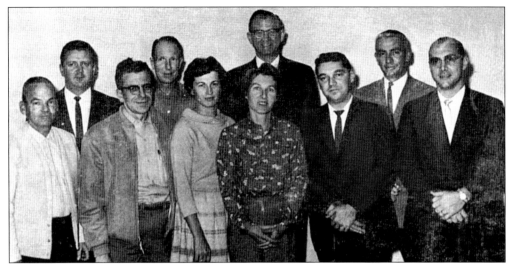

Established to create community and a way for residents to resolve issues through the democratic process of a town hall meeting, the Diamond Bar Homeowners' Association (DBHOA) saw its role and influence grow along with the area's population. In just a few years, the group's responsibilities expanded to include education and enforcement of Transamerica's county-approved property maintenance guidelines and preparation of a proposal to create a Municipal Advisory Council. The DBHOA was the first and strongest advocate for incorporation. In November 1986, the group changed its name to the Diamond Bar Improvement Association to better reflect its purpose and eliminate confusion with various other homeowners' associations. The above photograph shows the 1964 board of directors for the DBHOA. Pictured are, from left to right, (first row) Jack Tillery (Green Valley Estates), publicity; John Vaughan (Heritage Homes), adult recreation; Audrey Hatch (Westwood Ranchos), membership; Betty Stern (Westwood Ranchos), secretary; Peter Chiacchieri (Heritage Homes), emergency service; and Herb Dries (Heritage Homes), membership; (second row) Gordon Shaw (Golden Springs Estates), vice president; Ralph Phillips (Westwood Ranchos), treasurer; Albion Bjermeland (Westwood Ranchos), youth activities; and John Oakes (Green Valley Estates), president. Below is a photograph of Westwood Ranchos, where the DBHOA had its beginnings in October 1960 in a home on Prospect Valley Drive.

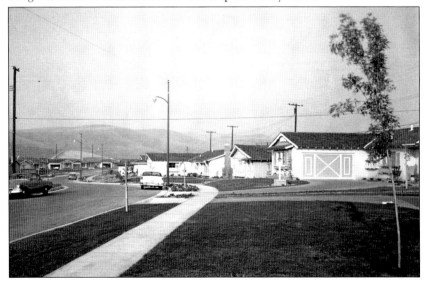

The DBHOA created the area's first community newsletter in 1960. The two-page document listed new residents, congratulatory messages, and upcoming social events; in 1962, it was named *The Windmill* in honor of the historic windmill that now stands at Diamond Bar Town Center. Monthly home delivery of *The Windmill* was one of the benefits Diamond Bar homeowners received through their DBHOA membership and annual $5 renewal fee; other benefits included voting rights and free admission to social events. The publication's look and design evolved several times; it became a full-color, gloss-stock publication in 2012 and is now produced bimonthly. The below image shows the windmill in 1974 (at right) and the early 1980s (at left). (Below right, courtesy of Robin McMullen Landgren.)

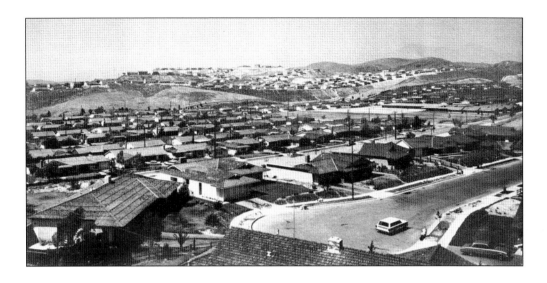

By the late 1960s, the Diamond Bar Homeowners' Association (DBHOA) had, more than once, given serious contemplation to the idea of incorporation but each time resisted because it felt the community was not yet fiscally prepared to take on the cost of local government. In 1971, however, the Senate presented the perfect prelude to Diamond Bar's incorporation through its creation of the Municipal Advisory Council (MAC) form of government, which was intended for communities like Diamond Bar that were located within unincorporated areas of a county. In June 1973, the DBHOA submitted its application for MAC status to Los Angeles County supervisor Pete Schabarum. Above is an aerial view of the Diamond Bar area in the 1960s; below is a northward view along Diamond Bar Boulevard.

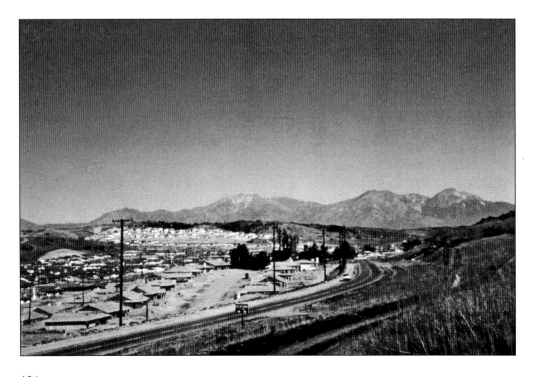

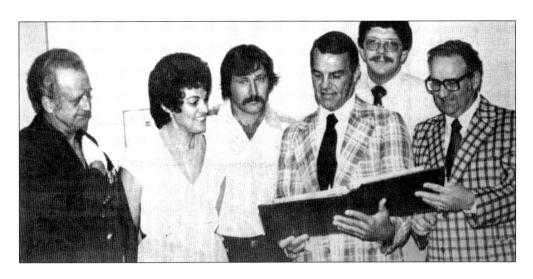

On November 2, 1976, Diamond Bar voters approved the creation of a five-member Diamond Bar Municipal Advisory Council (MAC), the only one of its kind at the time in Los Angeles County. Voters also selected Brenda Engdahl, Ronald Foerstel, George Resh, and Don Stokes to form part of the first council. The two highest vote-getters received four-year terms, with the other two taking a two-year term. The Los Angeles County Board of Supervisors later appointed the fifth MAC member, Richard Vind, to a four-year term. Pictured above are, from left to right, Dal Cabel, Engdahl, Foerstel, Los Angeles County supervisor Pete Schabarum, Jerry Long, and Stokes.

Diamond Bar
WW—Proposed advisory council

Yes	4,028	64.7
No	2,201	35.3

Advisory council

Engdahl	2,279	11.4
Foerstel	2,130	10.7
Resh	1,949	9.9
Stokes	1,941	9.8
Pine	1,904	9.5
Hall	1,383	6.9
Martin	952	4.8
Lineberger	925	4.6
Ragazzi	851	4.3
Larutta	842	4.2
Du Rant	814	4.1
Rentz	787	3.9
Newsom	767	3.8
Hildebrand	732	3.7
Guy	707	3.5
Staley	607	3.0
Rollheiser	370	1.9

Above are the first elected Diamond Bar Municipal Advisory Council (MAC) members (from left to right): Ronald Foerstel, George Resh, Brenda Engdahl and Don Stokes. Not pictured is Richard Vind, who was appointed by Los Angeles County supervisor Pete Schabarum. The MAC unofficially met for the first time on November 5, 1976, at Chaparral Intermediate School to discuss bylaws and volunteer committees. Vind joined the MAC in December 1976, at which time the group became the official liaison group between the community and the Los Angeles County Board of Supervisors.

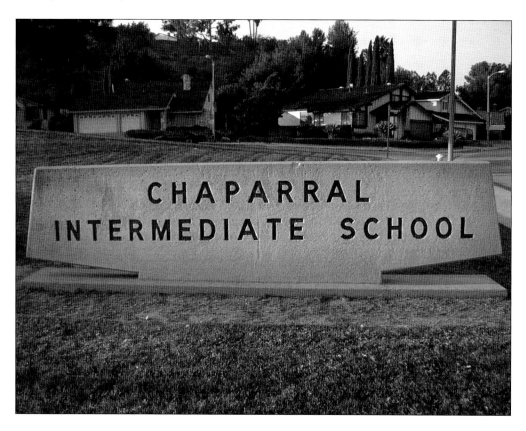

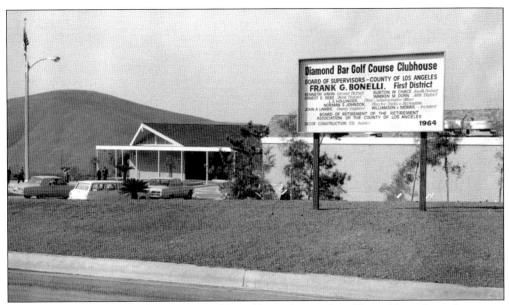

Diamond Bar Municipal Advisory Council (MAC) members gathered biweekly in the multipurpose room of the former Diamond Bar library building at 1061 Grand Avenue, which had a capacity of up to 75 people. Interested residents would attend the meetings and voice complaints about issues such as traffic, school sites, and new development. After forming in 1976, the MAC used a coat closet at the Diamond Bar Golf Course (above) as its first office, which had just enough space for a small filing cabinet. The group wanted a better facility, and in August 1979, they negotiated a deal with Los Angeles County to secure permanent office space (below) at Heritage Park in south Diamond Bar, which then housed recreation personnel. With the March 1989 election that incorporated the city and created an official Diamond Bar City Council, the MAC was no longer needed, and it was dissolved on March 14, 1989.

In 1979, new traffic signals were installed at Diamond Bar Boulevard and Grand Avenue after residents voiced safety concerns. Pictured at left are, from left to right, Robert Waller, president of the Diamond Bar Homeowners' Association; Pete Schabarum, Los Angeles County supervisor; Don Ury, Diamond Bar Development Corporation; Brenda Engdahl, member of the Diamond Bar Municipal Advisory Council (MAC); Tom Tidesmanson, Los Angeles County road commissioner; and Ron Foerstel, chairman of the MAC. The group is inspecting new traffic signals at the intersection of Diamond Bar Boulevard and Grand Avenue. The $55,000 improvement project included the installation of left-turn signals and highway safety lighting.

This 1960s photograph shows the intersection of Diamond Bar Boulevard and Grand Avenue. (Courtesy of the C. David Jewell family.)

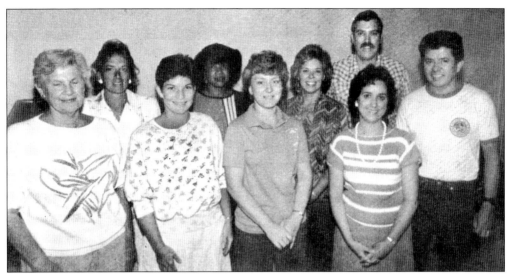

To help finance operations and elections, the Diamond Bar Municipal Advisory Council (MAC) organized an array of fundraisers. Among the MAC's most successful and lucrative fundraising efforts was the Diamond Bar Ranch Festival, first held at Lorbeer Middle School on October 5, 1985. Members of the inaugural Diamond Bar Ranch Festival Committee pictured here are, from left to right, (first row) Gini Spandau, Judy McFadden, Dale Griffin, and Susan Bill; (second row) Pam Stroud, Rachel Anderson, Donna Thompson, Dewey McFadden, and Ken Martinez.

Organized by a committee of 30 volunteers, the inaugural 1985 Diamond Bar Ranch Festival began with a pancake breakfast at 7:00 a.m., followed by a parade featuring 42 local organizations at 9:00 a.m., and continued until dusk with an assortment of activities including live entertainment, games, vendors, drawings, information booths, and concessions.

In 1986, the Diamond Bar Ranch Festival evolved into a two-day celebration, again held at the Lorbeer Middle School. In 1987, an extra day was added, and the festival moved to Peterson Park (formerly Sylvan Glenn Park). Also in 1987, the festival was spun off from the Municipal Advisory Council and became its own nonprofit 501(c)(3) corporation, complete with bylaws and a 15-member board of directors. In 1988, the festival moved to the Gateway Corporate Center, and the entertainment lineup was enhanced with big-name performers such as The Drifters and The Shirelles. The 1988 event attracted more than 45,000 people and raised more than $22,000; the following year, attendance nearly doubled at the festival, with 70,000 estimated attendees, and raised over $40,000. Below is an aerial photograph of the 1995 festival at the Gateway Corporate Center. (Below, courtesy of June Grothe.)

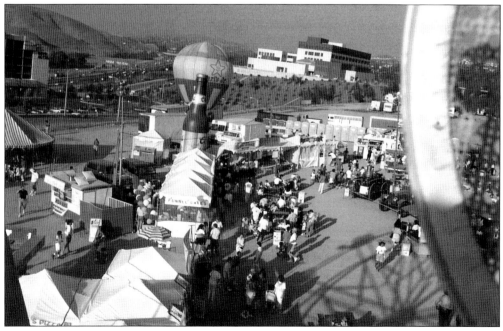

While many contributed to the establishment and success of the Diamond Bar Ranch Festival, Donna Thompson was instrumental in developing it into a highly entertaining, profitable, and popular event. Thompson became the festival's first chairperson in 1986 and led the efforts to establish an official nonprofit public benefit corporation in 1987. Thompson remained involved for five years, and upon her retirement, Los Angeles County supervisor Pete Schabarum presented her with a special scroll for her contributions.

While self-governance was something the Diamond Bar Homeowners' Association and, later, the Municipal Advisory Council (MAC) had contemplated since the early 1960s, it was not until 1982 that the idea materialized into submitting an application for incorporation to Los Angeles County officials. Despite a few challenges related to differing revenue-and-expenditure analysis and proposed city boundary lines, the county's Local Agency Formation Commission (LAFCO) voted in May 1983 to recommend that the incorporation proposal be placed on the November 1983 ballot. Above, MAC members—from left to right, Don Stokes, Dal Cabal, Brenda Engdahl, and Ron Foerstel—show a map of the territory originally sought for incorporation, which the LAFCO later removed before allowing the question to appear on the ballot. The measure was narrowly defeated in 1983, with voters rejecting incorporation 3,463 to 3,233. Below, pro-incorporation advocates await the results of the November 1983 election.

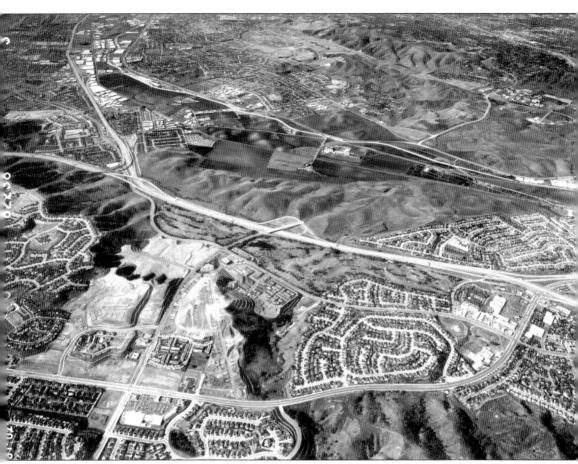

Two years after the failed incorporation drive in 1983, the growing sentiment of the Diamond Bar Homeowners' Association (DBHOA) and the Municipal Advisory Council—that the Los Angeles County board of supervisors had stopped being responsive to the community's needs by making decisions based on regional concerns—fueled an attempt by the DBHOA to get the issue of incorporation on the November 1986 general election ballot. This second drive for incorporation never reached the ballot because not enough signatures were collected in time to meet county deadlines. Longtime incorporation proponent Phyllis Papen chaired the incorporation committee, ran in the 1983 election for city council, and secured enough votes that she would have earned a seat had incorporation passed. This image offers an aerial view of Diamond Bar in the early 1980s.

WOULDN'T IT BE NICE TO BE WELCOMED HOME BY THIS BEAUTIFUL SIGN? TO FIND OUT ABOUT WHERE, WHEN AND HOW MUCH, COME TO THE FOLLOWING PUBLIC MEETINGS:

Monday, January 31, 1983, at Diamond Bar High School Theater, 7:30 p.m.
Saturday, February 5, 1983, at Diamond Point Elementary School, 10:00 a.m.
Monday, February 7, 1983, at Chaparral Intermediate School, 7:30 p.m.
Saturday, February 26, 1983, at Chaparral Intermediate School, 10:00 a.m.
Monday, February 28, 1983, at Lorbeer Junior High School, 7:30 p.m.

In the late 1970s and early 1980s, prompted by the impending departure of Transamerica after it sold off its last housing tract, the Municipal Advisory Council set out to determine how much funding would be needed to finance the installation and maintenance of existing and future landscape improvements within medians and parkways. Because of this effort, the area's first citywide Landscape Assessment District was formed and approved by the Los Angeles County Board of Supervisors in August 1984. The medians along Grand Avenue and Diamond Bar Boulevard were the first areas to receive attention with the funds raised through the new assessment. This illustration was the front cover of *The Windmill* magazine, which the Diamond Bar Homeowners' Association used as its primary vehicle to spread the word about the planned entry monuments.

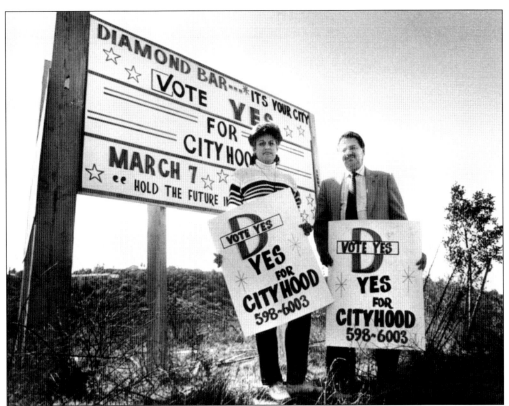

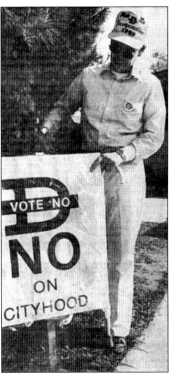

The incorporation proposal was originally scheduled to reach the ballot in November 1988, but a six-member anti-cityhood group made an 11th-hour request to the Los Angeles County Local Agency Formation Commission (LAFCO) to reconsider the application process and the subsequent county public hearing, causing the election to be delayed until March 7, 1989. This setback resulted in the city nearly losing out on more than $1 million in property tax revenue and shortened terms for three of the five city council members. The anti-incorporation group, chaired by the late Al Rumpilla (pictured at right), maintained that cityhood was economically impractical and that little would be gained in public services not already provided by Los Angeles County, and if services could be increased, it would cost residents more in taxes. Pictured above are incorporation committee members Brenda Engdahl (left) and Ivan Nyal.

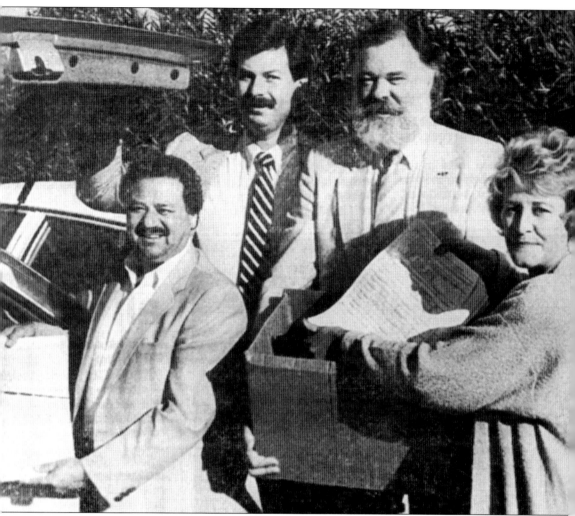

During their third attempt at incorporation, cityhood advocates at last saw their efforts pay off when they successfully concluded a seven-month campaign to raise funds and gather signatures to qualify for the Los Angeles County Local Agency Formation Commission (LAFCO) to review their request for the establishment of a local government. Above, from left to right, Ivan Nyal, Gary Werner, John Forbing, and Phyllis Papen prepare to deliver an $8,503 check and petitions bearing 6,100 signatures to county offices.

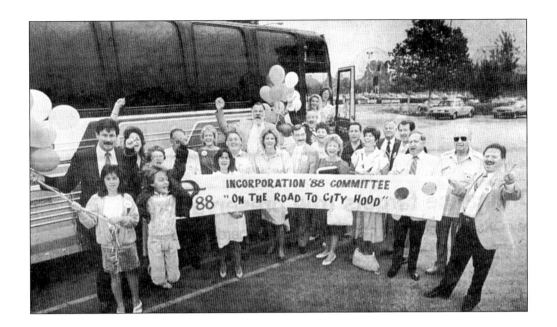

Optimistic that incorporation was within grasp, a group of about 70 cityhood supporters traveled to Los Angeles for a July 1988 hearing at which the Los Angeles County Local Agency Formation Commission (LAFCO) would vote on the approval of the proposed city boundaries and the inclusion of a cityhood proposition on the November 1988 ballot. The map shown below outlined the proposed Diamond Bar city boundaries.

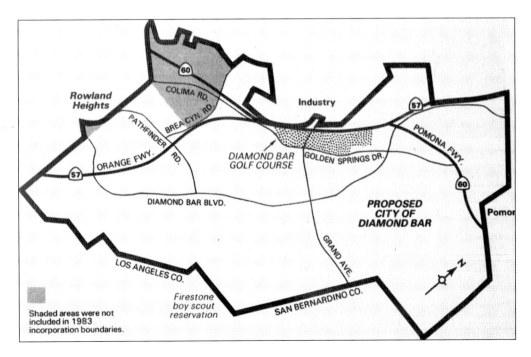

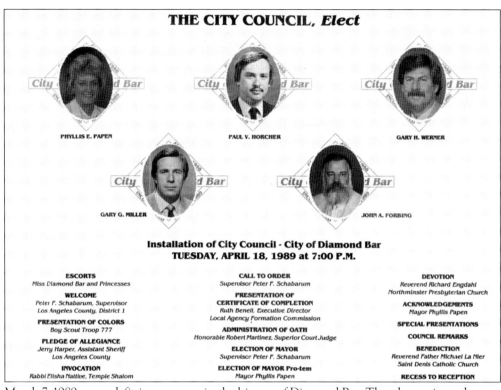

March 7, 1989, was a defining moment in the history of Diamond Bar. That day, registered voters sided with leading incorporation proponents by a margin of 76 percent to 24 percent, confirming that the community was ready to become its own city. On the same ballot, voters also selected Phyllis Papen, Paul Horcher, Gary Werner, Gary Miller, and John Forbing to serve as the first Diamond Bar city council. They also voted in favor of electing future city council members on an at-large basis instead of by separate districts. Pictured below in front of Diamond Bar City Hall in 1989 are, from left to right, Forbing, city manager Robert Van Nort, Papen, Horcher, Miller, and Werner.

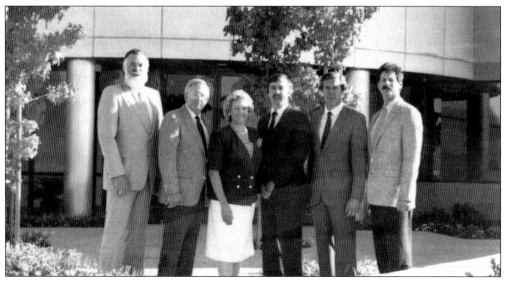

Five

GROWTH OF A CITY
THE FIRST 25 YEARS

With the incorporation election results certified by Los Angeles County on March 21, 1989, the newly elected Diamond Bar City Council dived into the thick of creating the new city.

In the weeks leading up to its official installation ceremony, the group met several times to organize for the establishment of the soon-to-be seat of local government—the tasks included securing office space for city hall, hiring key city personnel, meeting with the county to ensure continuity of services, and drafting resolutions and ordinances.

The official incorporation of the city occurred on Tuesday, April 18, 1989, during the city council's first official meeting, which was held in the Chaparral Intermediate School auditorium and attended by more than 300 people.

The meeting opened with an installation ceremony that included the administration of oaths to council members, the election of mayor Phyllis Papen, mayor pro tem Paul Horcher, and special presentations and well-wishes from several state, county, and local officials.

The city council also had the complex yet exciting task of formulating the city's first official general plan, required by state law to be completed within 30 months after incorporation, to serve as a "blueprint" for future land-use planning.

To help undertake this city-defining task, the council appointed 30 residents to serve on an ad hoc advisory committee tasked with creating a brand-new plan that would align with the city's vision for maintenance and growth.

The final Diamond Bar general plan was adopted by the city council on July 25, 1995, marking an important milestone for the community—tangible proof of the local control they had sought with the incorporation of the city six years earlier.

Looking forward to the next 25 years and beyond, the current city council plans to continue the tradition of protecting the city's firm financial foundation through prudent revenue and appropriation policies and decisions started by the founding council and maintained by the five generations of councils that have followed.

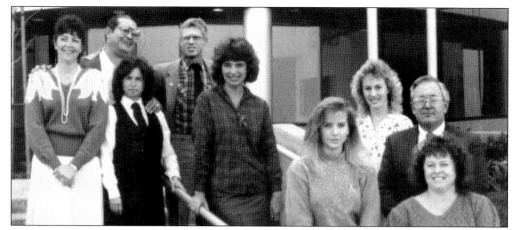

After the March 7, 1989, election and before its first meeting on April 18, 1989, the city council–elect took on the task of establishing the first city manager's office. Since the council had not yet been sworn in and therefore was not an official body, the first city employees—the city manager, an attorney, and a secretary—were brought in by the council-elect on an interim basis and without a formal agreement. Pictured on the front steps of the first city hall offices in the Gateway Corporate Center are, from left to right, city clerk Lynda Burgess, building inspector Al Flores, deputy city clerk Tommye Cribbins, Matthew Fournatt, secretary to the city manager Dawne Calleros, junior clerk typist Christine Haraskin, financial management assistant Joann Saul, city manager Robert Van Nort, and senior accountant Linda Magnuson.

The first year of cityhood was trying on the new Diamond Bar City Council because in addition to learning the operation of the city and their roles as policy makers, they faced a challenges during the first year that included responding to a lawsuit by the County of San Bernardino, undertaking efforts to widen the Pathfinder Bridge over the Route 57 freeway without any funding, and the withholding of property tax revenue by Los Angeles County due to a legal interpretation regarding the city's incorporation date. The city held its first birthday celebration on April 17, 1990, at Sycamore Canyon Park. Pictured here are, from left to right, councilman Paul Horcher, future councilman Jay Kim, councilman Gary Werner, councilman Gary Miller, mayor Phyllis Papen, and councilman John Forbing.

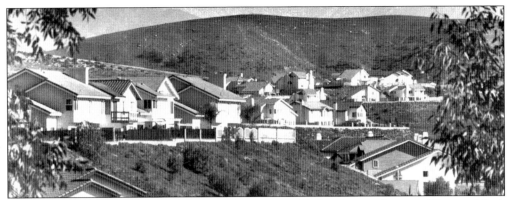

Local control, the primary motivation for incorporation, added to the significance of Diamond Bar's first general plan as an incorporated city. The initial draft of the "blueprint for development" was finished in 1990 with the assistance of a 30-member, community-based advisory committee. The plan generated a rift among residents who advocated for more restrictive development and those who saw development as critical to the long-term sustainability of the city. Six years, three drafts, and two advisory committees later, the Diamond Bar City Council adopted the city's first general plan on July 25, 1995. Almost 20 years later, in 2014, the city began the process of executing the first comprehensive update to its general plan to guide new development into the next two decades. This photograph shows Diamond Bar Homes in the 1990s.

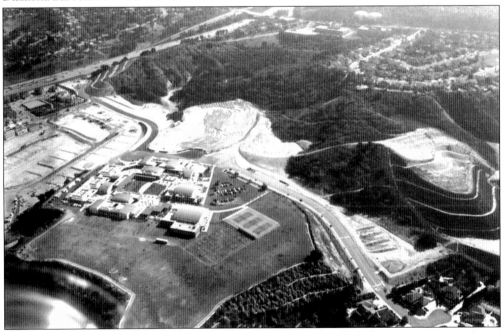

In the spring of 1993, the city pursued the opportunity to master-plan a large area of undeveloped land. This was of major significance because prior to incorporation, decisions regarding land use were made by Los Angeles County. The South Pointe Master Plan guided the development of 170 acres in the South Point Middle School/Sandstone Canyon area (west of Brea Canyon Cut Off and north of Pathfinder Road). Implementation of this plan replaced South Point Middle School's temporary structures with permanent buildings on a 30-acre area. The remaining 140 acres contained 90 acres of housing; 30 acres of commercial, retail and office space; and 20 acres of parkland. This aerial photograph is of the South Pointe development.

One of the first major capital improvement projects the city undertook as an incorporated entity was the reconstruction of the Heritage Park Community Center. The project, aimed at creating a facility that could accommodate a wider range of recreational uses, nearly doubled the size of the previous building from 2,000 to 3,700 square feet of space. A special event was held to mark the grand reopening of the center on September 11, 1993. Among those pictured at the event are councilman Gary Werner, mayor Phyllis Papen, councilman John Forbing, councilman Gary Miller, and members of the Miss Diamond Bar Princess court.

Pantera Park was the first—and, to date, the only—community park fully planned and constructed by the city following incorporation. Based on citizen input obtained through four community meetings, the 23-acre park site was outfitted with two softball fields, three basketball courts, a children's play area, a meeting room, concession facilities, and picnic areas. Elected officials and community representatives came to the grand opening celebration in July 1998, including, from left to right, former councilwoman Eileen Ansari, Bob Huff (now a state senator), councilman Wen Chang, supervisor Don Knabe, councilwoman Debbie O'Connor, councilwoman Carol Herrera, and members of the Miss Diamond Bar court. In November 2012, Pantera Park was expanded to include the city's first dog park.

The path that led to the construction of the Diamond Bar Center began in 1998 with the formation of a 35-member community task force appointed by the Diamond Bar City Council. After 18 months of considering various options and gathering public input, the group recommended construction of a community/senior center at Summitridge Park. Construction of the Diamond Bar Center began in July 2002 and took nearly two years to complete. The 22,500-square-foot facility opened to high acclaim on Saturday, March 20, 2004. Pictured below ceremoniously cutting the ribbon on grand opening day are, from left to right, councilman Wen Chang, councilwoman Deborah O'Connor, congressman Gary Miller, councilman Bob Zirbes, councilman Bob Huff, and councilwoman Carol Herrera.

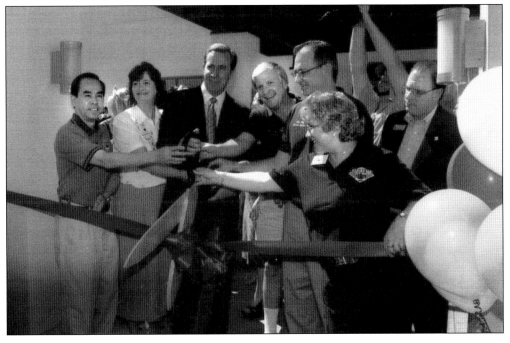

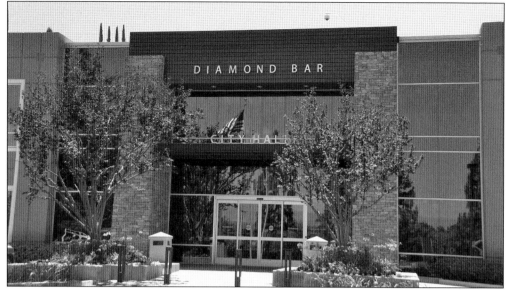

After more than 21 years of renting, the city council took advantage of the availability of a two-story building within the Gateway Corporate Center and secured a permanent address for both city hall and an expanded library. The building was purchased in 2010 with $10 million of the city's general fund reserves. On January 3, 2012, Diamond Bar City Hall began serving the public from its new location on the second level of this building. The new library opened on July 30, 2012. The library's relocation from Grand Avenue doubled the floor space and increased the number of parking slots from 35 to 300. The new library was dedicated on Saturday, July 28, 2012, with special recognition given to Los Angeles County Fourth District Supervisor Don Knabe for his allocation of $5 million for the construction of the library and the Diamond Bar Friends of the Library organization for its donation of $80,000 for the construction of a reading garden. Pictured below at the grand opening are, from left to right, Laura Zucker, executive director of the Los Angeles County Arts Commission; councilman Jack Tanaka; state senator Bob Huff; congressman Ed Royce; councilwoman Carol Herrera; councilwoman Ling-Ling Chang; Knabe; congressman Gary Miller; Diamond Bar Friends of the Library president Rosette Clippinger; county librarian Margaret Donnellan-Todd; and Diamond Bar Friends of the Library member Ruth Low.

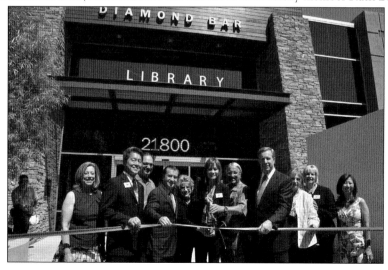

When the South Coast Air Quality Management District relocated to its new headquarters within the Gateway Corporate Center in October 1991, it became the largest employer in Diamond Bar and has since kept that title with an average of 720 employees. The facility is approximately 350,000 square feet and includes a two-story laboratory building, two office buildings (three and five stories high), and a 450-seat auditorium. When the AQMD board unveiled plans for new headquarters in December 1988, it was said to feature "futuristic" energy provisions such as solar energy and fuel cells. In August 2004, the AQMD headquarters made news when it unveiled one of its first hydrogen fueling stations for public use.

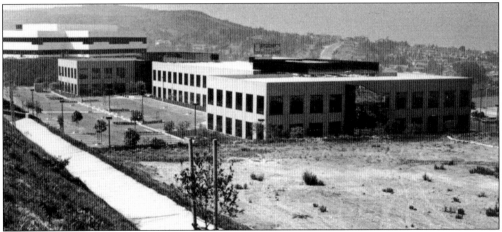

Situated on 255 acres of hillside land with panoramic views of the San Gabriel Valley, the Gateway Corporate Center is one of the largest corporate office parks in East San Gabriel Valley. The business park, designed for corporate headquarters, is conveniently located at the intersection of the Pomona (Route 60) and Orange (Route 57) Freeways. More than two-thirds of the land is dedicated as permanent space, with the remaining land divided into 23 lots comprising 77 buildable acres. The first company in the office park was Kelley-Clarke, Inc., which arrived in 1987. Kelley-Clarke has since relocated, but the office park continues to attract nationally known and Fortune 500 companies. In 2014, a Kaiser medical facility expansion project to build a two-story addition to an already existing building signaled development of the last vacant parcel of land within the Gateway Corporate Center.

The Diamond Bar Town Center contains a 30-foot-tall windmill that serves as a reminder of the area's past. The windmill (pictured above in the early 1980s) is said to have been operational during the Diamond Bar Ranch days at a location approximately 200 yards away from where it now stands. Supposedly, the windmill survived the demolition of all things ranch-related during development of the area in the early 1970s because Don Ury, then vice president of the Diamond Bar Development Company, moved the windmill to ensure that it escaped unscathed. Once the shopping center was completed, the windmill was brought back and welded in place near the corner of Diamond Bar Boulevard and Grand Avenue. In 2005, the Diamond Bar Breakfast Lions led an effort to recognize the windmill as a historical landmark. Among those pictured below at a 2005 event to recognize the windmill's historical importance are councilman and member of the Diamond Bar Lions Club Jack Tanaka, Diamond Bar Historical Society president John Forbing, councilwoman Carol Herrera, Lions Club member Wanda Tanaka, and Bill Bartholomae (son of former Diamond Bar Ranch owner William Bartholomae).

Since the city's incorporation in 1989, Diamond Bar has operated as a general law city under an elected city council–appointed city manager form of government. Among other things, the city council is responsible for establishing local laws, setting policy, adopting an annual budget, and appointing community members to serve on the city's three advisory commissions—parks and recreation, planning, and traffic and transportation. Council members are elected every four years, with elections held every November in odd years. Each December, the council elects from its membership a mayor to serve as the presiding officer for a one-year term. Members of the 2014 Diamond Bar City Council are pictured here; they are, from left to right, councilwoman Nancy A. Lyons, mayor pro tem Steve Tye, mayor Carol Herrera, and council members Ling-Ling Chang and Jack Tanaka. Page six of this book contains a complete list of all members of the Diamond Bar City Council and their years of service.

The official city seal was adopted by the Diamond Bar City Council in October 1989. The seal was designed by Jackson T. Wyse, a graphic artist and Diamond Bar High School graduate, with finish work done by architect David Eskridge. The seal's main elements pay homage to the city's working cattle ranch days, when windmills were used to pump water and Frederick E. Lewis's registered ranch brand was a diamond with a bar above it. The hills are characteristic of the city's landscape, the trees are symbolic of the environmental awareness of the community, and the building represents the first city hall. The image at right shows Wyse's initial concept, and the finished seal is visible behind the city council members in the above photograph.

Discover Thousands of Local History Books
Featuring Millions of Vintage Images

Arcadia Publishing, the leading local history publisher in the United States, is committed to making history accessible and meaningful through publishing books that celebrate and preserve the heritage of America's people and places.

Find more books like this at
www.arcadiapublishing.com

Search for your hometown history, your old stomping grounds, and even your favorite sports team.

Consistent with our mission to preserve history on a local level, this book was printed in South Carolina on American-made paper and manufactured entirely in the United States. Products carrying the accredited Forest Stewardship Council (FSC) label are printed on 100 percent FSC-certified paper.